IMAGES
of America

WILKES-BARRE

IMAGES
of America

WILKES-BARRE

Elena Castrignano

ARCADIA
PUBLISHING

Published by Arcadia Publishing
Charleston, South Carolina

Printed in the United States of America

Library of Congress Control Number: 2012941982

For all general information, please contact Arcadia Publishing:
Telephone 843-853-2070
Fax 843-853-0044
E-mail sales@arcadiapublishing.com
For customer service and orders:
Toll-Free 1-888-313-2665

Visit us on the Internet at www.arcadiapublishing.com

*This book is dedicated to Jim, for his love and support, and
to my mom, Janet, for her stories of old Wilkes-Barre.*

CONTENTS

ACKNOWLEDGMENTS

Wilkes-Barre would not have been possible without the generosity of the Luzerne County Historical Society. Thanks go especially to executive director Anthony T.P. Brooks and director of library and archives Amanda C. Fontenova for their endless assistance, as well as to the members of the board for allowing me to use their photographs in this book. Thank you.

To my long-suffering editor at Arcadia Publishing, Abby Henry, thank you for all of your help and for keeping me on track to my deadline.

I must thank my sons, Michael and Stephen, for their assistance in selecting images for this book, especially the cover.

I must also send an enormous note of gratitude to Mia Bassham, the best boss ever, for her encouragement and support.

Unless otherwise noted, all images are courtesy of the Luzerne County Historical Society.

INTRODUCTION

The city of Wilkes-Barre has a history as diverse as that of any town or city in the United States. The area was originally settled by the Native Americans who followed the Susquehanna River north into what would become the Wyoming Valley.

Susquehanna derives its name from the Native American word *Sus-que-han-nock,* which meant "broad, shallow river." The river was rich in shad, trout, and catfish, and the Native Americans were able to grow what they needed in the fertile land. The hunting of deer and other wild creatures also provided food.

The Native Americans called the Wyoming Valley *Maugh-wau-wa-me,* meaning "large plains" or "meadows." The white man turned the name into "Wyoming." The area of Wyoming was part of lands claimed by the Iroquois, also known as the Six Nations. The Connecticut Susquehanna Company wrongly claimed the territory as part of the Connecticut colony and purchased the land from the Iroquois. They settled the area in 1762, at the site of the present-day Hollenback Cemetery. This settlement was raided by a warring band of Native Americans in October 1763, and the settlers returned to Connecticut.

Thomas and Richard Penn, who believed themselves the rightful owners of the land in the Wyoming Valley, were annoyed when they learned of the Connecticut Susquehanna Company's attempt at settlement. Once again, the Iroquois were paid for the land, this time by the Penns, in November 1768.

In 1769, the Connecticut settlers returned to the valley, eventually building a fort in what is now the city of Wilkes-Barre. The fort was named for the group's leader, Maj. John Durkee. Durkee began to lay out the town, creating paths that would eventually become roads, erecting log buildings, and giving the town a name. He called it Wilkesbarre.

From then until today, the city of Wilkes-Barre grew and evolved; it was incorporated as a borough on March 17, 1806, and chartered as a city on May 4, 1871. On January 3, 1972, the areas known as Parsons and Miners Mills were annexed to the city.

How the city grew and changed is the subject of *Wilkes-Barre.* The changes occurred thanks to individuals—those who came to the valley to work in the coal mines; those who created industries and businesses; those who taught the children; and so many more. The city of Wilkes-Barre has been home to some famous people, such as Joseph and Herman Mankiewicz, who became filmmakers, screenwriters, and Academy Award winners in California. The Mankiewicz family came to Wilkes-Barre from New York when Herman's father, a German immigrant, was offered a teaching position. Joseph was born in Wilkes-Barre in 1909, and the family returned to New York City four years later. Ham Fisher, born in Wilkes-Barre in either 1900 or 1901, created the Joe Palooka cartoon in 1920, getting it into print in 1928. It became a nationwide success, spawning several films from the 1930s to the 1950s. There is a monument to Joe Palooka along Route 309 just outside of Wilkes-Barre. Franz Kline, born in the city on May 24, 1910, became an abstract impressionist painter in the same league as Jackson Pollock.

The man who changed the face of the city completely was Judge Jesse Fell, who, on February 11, 1808, successfully burned anthracite coal in an open grate to provide heat. Fell had been experimenting with various methods of burning the coal for heat. Fell's discovery led to a boom for the city. Until then, the primary heating fuel had been wood, which was running out in big cities such as New York and Philadelphia. The Wyoming Valley's location along the Susquehanna River and in close proximity to those cities gave it an advantage. Soon, breakers were popping up throughout the valley, and coal was making some people wealthy. The breakers attracted immigrants, first from England, Wales, and Scotland, who were familiar with the workings of mines. Then, immigrants came from other parts of Europe, including Germany, Italy, and Poland. This immigration continued until about the time of the commencement of the American Civil War.

One city resident made direct changes to the lives of blacks in the 1800s. William C. Gildersleeve was an abolitionist and station master on the Underground Railroad. The railroad followed the rivers north into Canada, offering freedom for the slaves who took it. Wilkes-Barre is not a well-known station on the Underground Railroad, as Gildersleeve did not attract attention to his work, probably because most of the citizens of the city believed that abolitionists were breaking the law by aiding the escape of slaves from their owners. Before his death, Gildersleeve founded the Home for Friendless Children in Wilkes-Barre, donating $10,000 to its funding. The home is now part of the Children's Service Center on South Franklin Street.

Education in the valley has changed, assuming a progressively more prominent place in the city over the years. Initially, schooling took place at home beside the fire, then, in a one-room neighborhood schoolhouse. The next stage was a multiple-grade neighborhood school, then several schools offering classes from kindergarten to 12th grade. Finally, the first secondary school, Wilkes, was built in the city. At one point in time, the city was home to three college-level schools: Wilkes College, Kings College, and Luzerne County Community College (LCCC).

Luzerne County Community College was created just two years after the Pennsylvania Legislature passed the Community College Act of 1963, when the county commissioners agreed to act as sponsor of a two-year college. The commissioners appointed county school directors to survey the needs of high school students as well as local employers. The Pennsylvania Board of Education approved the plan for the community college on September 15, 1966. The school began formal operations a year later, on October 2, 1967, with 836 students in downtown Wilkes-Barre. The college offered 11 programs at $12.50 per credit. The following year, class size doubled as coal-mining jobs were being phased out and new businesses and industries moved into town. LCCC offered what employers needed: people skilled in the newest technologies. The college offered open admission (any county resident could attend classes), low tuition, varied academic and technical programs, and a commitment to provide a quality education. In its first five years, Luzerne County Community College served over 5,000 students and quickly outgrew its buildings in Wilkes-Barre. So, in January 1974, the college moved south into Nanticoke.

Throughout the years, many people have visited Wilkes-Barre, from vaudeville performers to presidents of the United States. The local theaters gave some vaudeville companies a start on the road to New York City. It was said that if you could make it in Wilkes-Barre, you could make it anywhere. There must have been some tough audiences in the city during that period of time. Naturally, presidential candidates came here to campaign for votes; more recently, the residents of the Wyoming Valley have seen many presidential contenders. In the early days, when travel was difficult, it was a special occasion to have a president visit the area.

Modes of travel changed throughout the years. Native Americans arrived in the valley on foot, along the Great Warriors Trail, which ran parallel to the Susquehanna River, or on the river in wooden canoes. Settlers from Connecticut and Philadelphia arrived on horseback or in wagons pulled by horses. Horses remained the mode of travel until the railroad came to town in 1834. Trolley travel began in 1888 and continued until 1950; at the height of its popularity, trolley lines crisscrossed the entire Wyoming Valley and beyond.

One

GROWTH OF A CITY

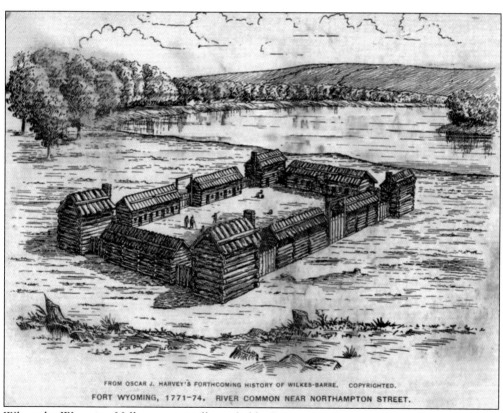

FROM OSCAR J. HARVEY'S FORTHCOMING HISTORY OF WILKES-BARRE. COPYRIGHTED.

FORT WYOMING, 1771–74. RIVER COMMON NEAR NORTHAMPTON STREET.

When the Wyoming Valley was initially settled by Europeans, there was confusion as to which colony had ownership—both Connecticut and Pennsylvania claimed the land. This was due to King Charles II of England, who had granted Connecticut the area in 1662, and in 1681 granted the same land to William Penn. The Native Americans also believed the land was theirs, and they sold it to both groups. The Connecticut settlers built Fort Durkee and set about creating a town around the fort; the Pennsylvanians built Fort Wyoming, shown here.

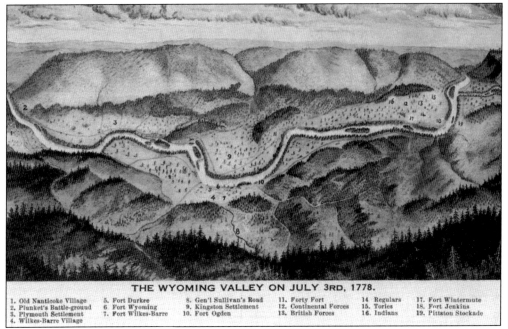

THE WYOMING VALLEY ON JULY 3RD, 1778.

1. Old Nanticoke Village	5. Fort Durkee	8. Gen'l Sullivan's Road	11. Forty Fort	14 Regulars	17. Fort Wintermute
2. Plunket's Battle-ground	6. Fort Wyoming	9. Kingston Settlement	12. Continental Forces	15. Tories	18. Fort Jenkins
3. Plymouth Settlement	7. Fort Wilkes-Barre	10. Fort Ogden	13. British Forces	16. Indians	19. Pittston Stockade
4. Wilkes-Barre Village					

This late-18th-century map, with important sites of the time noted at the bottom, shows a very early view of the Wyoming Valley. The Susquehanna River is shown running through the center of the map, as it does in the valley. It appears that all of the islands in the river are also shown.

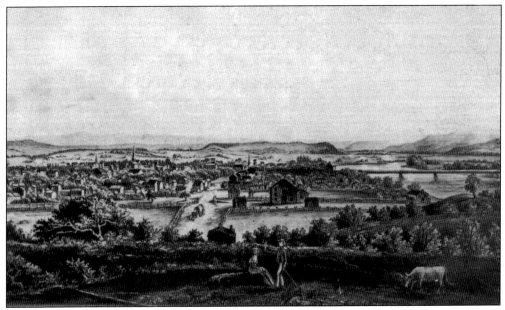

This painting offers an early view of the city of Wilkes-Barre as seen from what is now North Street on the King's College campus. The Susquehanna River is seen on the right side of the image. The dirt road in the center is in the area of North River Street. The Old Ship Zion Church steeple can be seen in the distance.

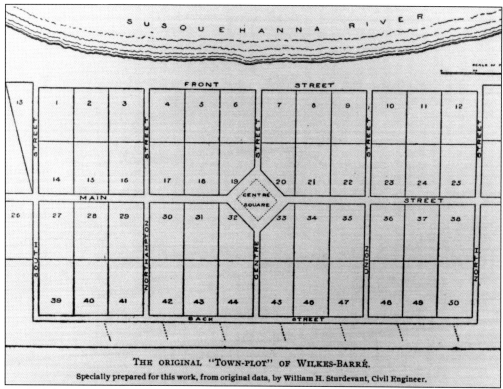

THE ORIGINAL "TOWN-PLOT" OF WILKES-BARRÉ.

Specially prepared for this work, from original data, by William H. Sturdevant, Civil Engineer.

As the label on this drawing states, this is the original layout of the town of Wilkes-Barre. Each plot is three acres in size, and they were parceled out by lottery. Note the street names; very few have been retained up to today. Front Street, of course, is now River Street; Back Street is now Pennsylvania Avenue; and Franklin and Washington Streets were not yet established. Plot number 50 belonged to the Slocum family, whose daughter Frances was kidnapped by Native Americans in 1778.

This map shows a bird's-eye-view of Public Square. Today, the square is not dissected by Main and Market Streets, but, according to this map, it once was. This map indicates the location of the buildings that were once on the square, including the first courthouse.

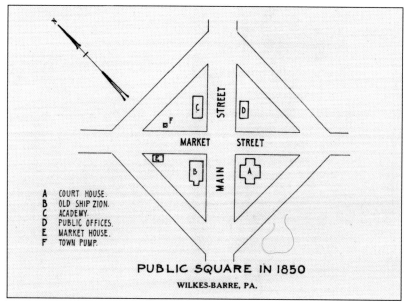

A COURT HOUSE.
B OLD SHIP ZION.
C ACADEMY.
D PUBLIC OFFICES.
E MARKET HOUSE.
F TOWN PUMP.

PUBLIC SQUARE IN 1850
WILKES-BARRE, PA.

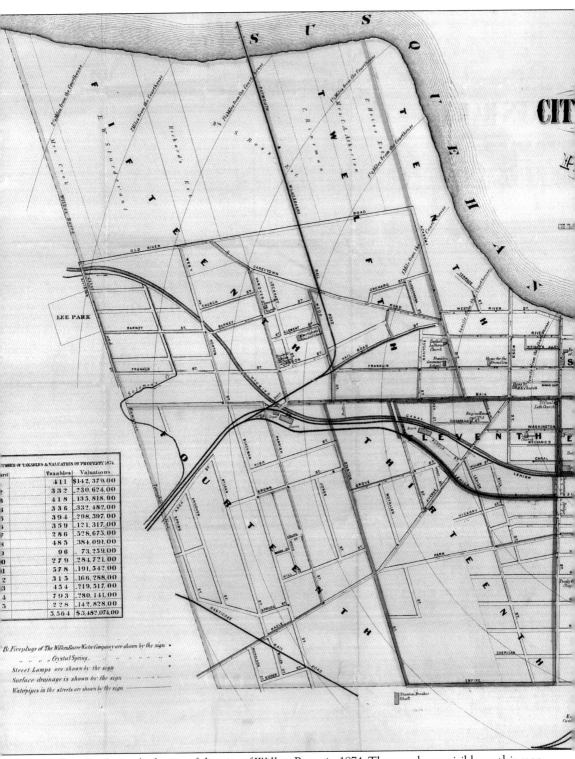

NUMBER OF TAXABLES & VALUATION OF PROPERTY 1874.		
ard	Taxables	Valuations
	411	$142,379.00
	332	230,624.00
	418	135,818.00
	336	332,482.00
	394	298,397.00
	359	121,317.00
	286	528,675.00
	485	384,091.00
	96	73,259.00
	279	284,721.00
	578	191,542.00
	315	166,288.00
	454	219,517.00
	793	280,141.00
	228	142,828.00
	5,564	$3,482,074.00

B: Fireplugs of The Wilkes Barre Water Company are shown by the sign •
" " " Crystal Spring.
Street Lamps are shown by the sign
Surface drainage is shown by the sign
Waterpipes in the streets are shown by the sign

This map shows the layout of the city of Wilkes-Barre in 1874. The canals are visible on this map; they were closed in 1882. Roads that no longer exist can also be seen on this map. What is not

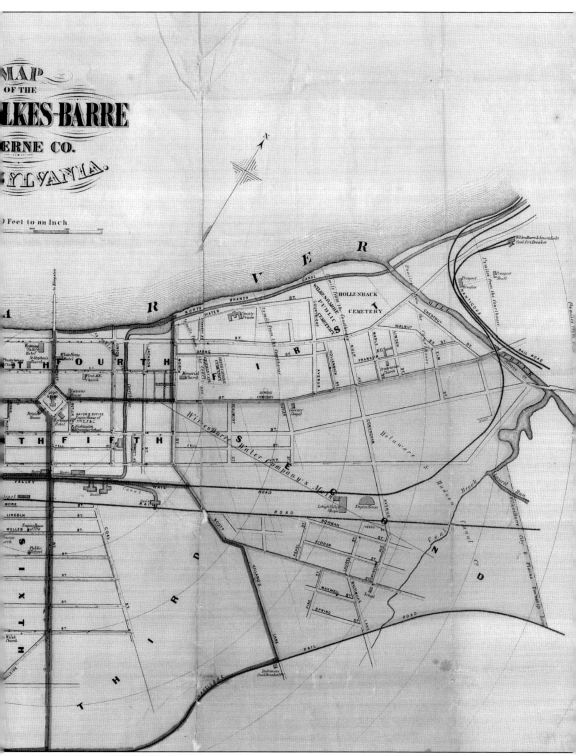

shown is Parsons and Miners Mills, now communities that are part of the city.

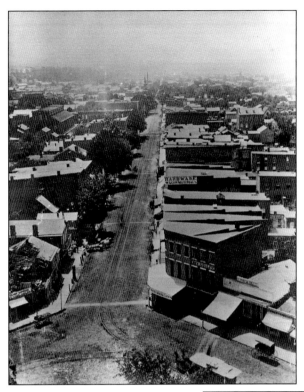

This photograph, taken from atop the courthouse on Public Square, offers a view of South Main Street and the southern section of Wilkes-Barre around 1875. The streetcars are being pulled by a team of horses along the tracks, which appear to run around the square and down South Main Street.

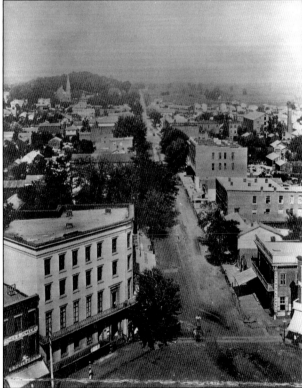

This c. 1875 photograph shows a view of North Main Street. The Memorial Presbyterian Church, on what was Bowman's Hill, now North Street, can be seen in the upper left of the photograph, in front of the trees. In the upper right, what looks like a farm and open fields are visible.

This photograph shows the business along the north side of Public Square around 1870. Horse-drawn carts are used for deliveries along the dirt road. Among the businesses that can be identified is a sewing machine store. The four-story building with the porches in the center of the photograph is a hotel. The building is the oldest hotel site in Wilkes-Barre. Over the years, it was the Exchange Hotel, the White Swan, and the Fort Durkee Hotel.

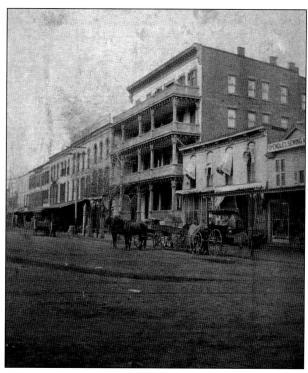

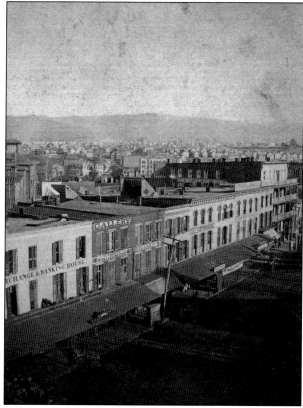

Looking west, this c. 1870 photograph shows the various businesses along the north side of Public Square. In this interesting look at early downtown Wilkes-Barre, note the awnings over the walkways.

15

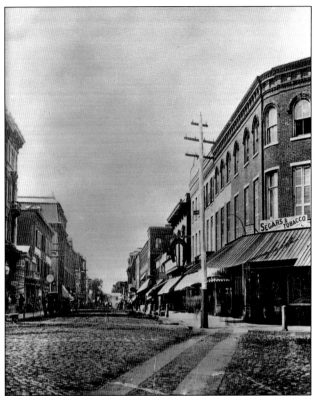

This c. 1885 photograph is a view down West Market Street from Public Square. The street was paved with cobblestones in 1866. Along the street are hitching posts for securing horses—early parking spots. The Market Street Bridge tollhouse can be seen at the end of the street. This block of buildings, along West Market Street, was the scene of the Great Fire of 1867, one of the worst fires in the history of the city. Since most of the structures along West Market Street, Public Square, and Franklin Street were destroyed, the buildings seen in this photograph are those that were reconstructed.

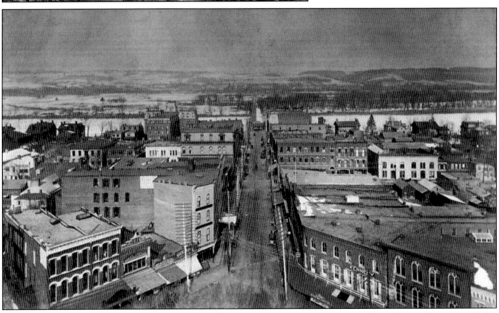

This c. 1887 photograph, another view of West Market Street, was taken from the top of the courthouse. The Wyoming Valley Hotel can be seen along River Street, the Market Street Bridge is at the end of the street, and the Susquehanna River can be seen flowing beneath the bridge. In the background on the left is what is now Kirby Park, and in the center and at right is what is now Kingston.

This photograph from the 1880s shows the Luzerne House, located where the Ramada Hotel is today. It appears the building is decked out for some sort of celebration.

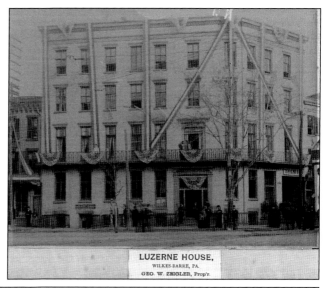

LUZERNE HOUSE,
WILKES-BARRE, PA.
GEO. W. ZEIGLER, Prop'r.

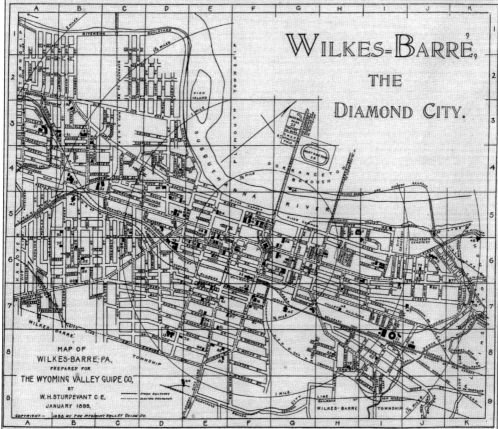

This map of the city of Wilkes-Barre is dated January 1899 and was completed by W.H. Sturdevant. Unlike the map on pages 12–13, this one shows parts of Parsons but still not Miners Mills. In addition, properties on the west side of the Susquehanna River are shown on this map. (Author's collection.)

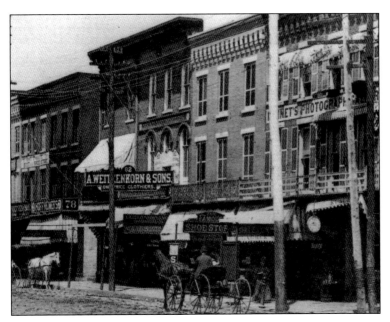

This old photograph, date unknown, shows a row of businesses along a dirt-covered street somewhere in the city of Wilkes-Barre. (Author's collection.)

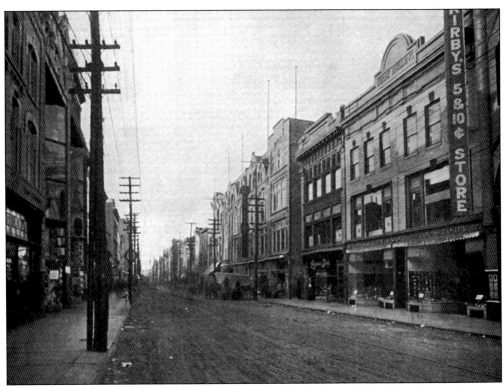

This photograph shows a dirt-covered South Main Street around 1906. On the right side is an early Kirby's 5-and-10-cent store. Farther down the street, a sign for the Boston Store is attached to a building. The other businesses, unfortunately, cannot be identified.

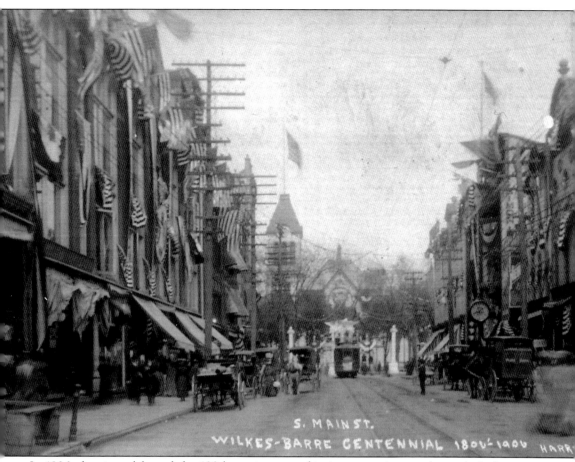

S. MAIN ST.
WILKES-BARRE CENTENNIAL 1806-1906 HARR

In 1906, the city celebrated the 100th anniversary of its incorporation as a borough. In honor of the celebration, just about every downtown building was decorated with red, white, and blue banners and drapes. US flags were everywhere. This photograph shows South Main Street, looking toward Public Square. The courthouse is visible in the center.

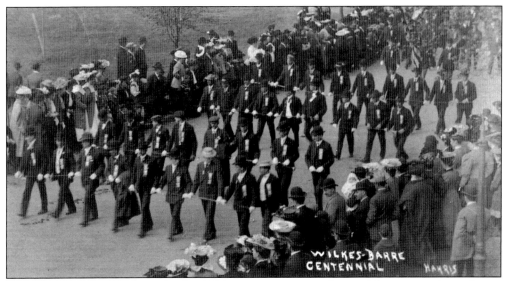

One of the many celebrations for the 100th anniversary was a huge, elaborate parade, as shown in this photograph. It appears that the entire population of the city, as well as surrounding areas, came out to see the parade. The people were dressed in their finest, too. The women had on their veiled bonnets, and the men were in their bowler hats.

This photograph shows a busy West Market Street in the 1920s, looking toward the Market Street Bridge. On the left, the Wyoming Valley Trust Company building can be seen, and in the distance, the tollbooth on the Market Street Bridge is just visible. This photograph, taken before the installation of traffic lights, shows a police officer directing traffic.

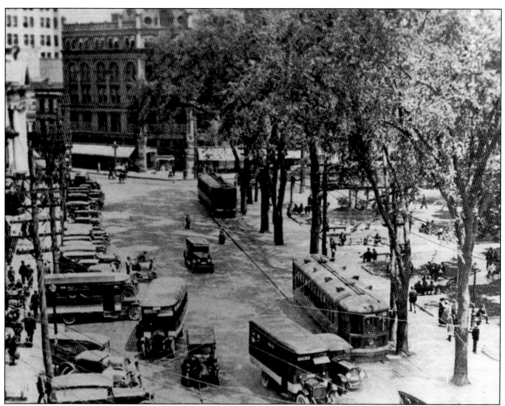

Seen here is a busy, bustling Public Square around 1920. Streetcars are lined up around the square, waiting for passengers or dropping them off; buses are working their way around cars, including one that seems to be broken down; and people seem to be everywhere. The building in the background appears to be Jonas Long's Department Store, now the site of the Wilkes-Barre Chamber of Commerce and an off-campus site of Luzerne County Community College.

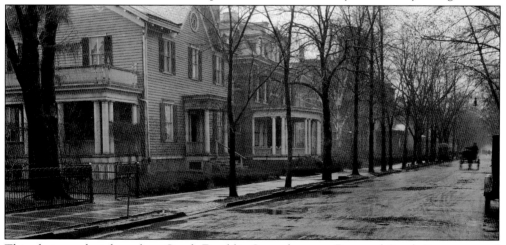

This photograph, taken along South Franklin Street between Ross and South Streets around 1922, shows the lovely homes that once lined the street. It also shows that potholes are nothing new; even when the roads were made of dirt, they still had potholes. These dwellings are now part of the Wilkes University campus.

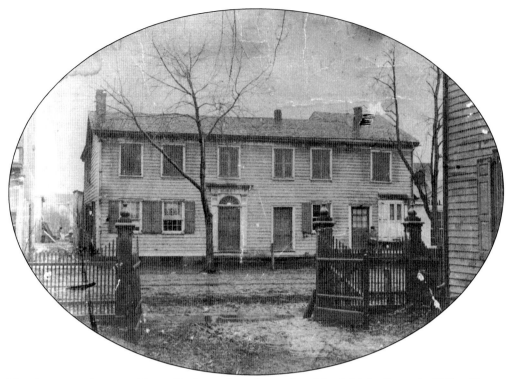

This house was home to Nancy Drake and was located on North Main Street in Wilkes-Barre. This is a typical 1800s family home in the city. The lace curtains on the windows probably came from the local lace mill.

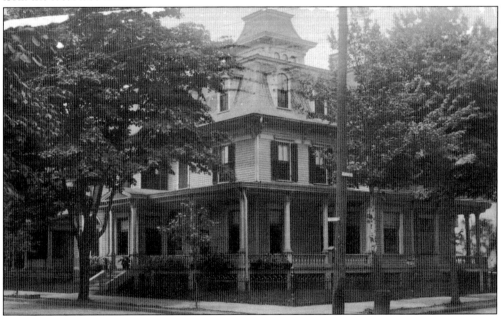

This photograph shows a beautiful home located at the corner of Academy and South Franklin Streets. This image illustrates some of the amazing architecture and elaborate homes that were built in the southern section of the city. (Author's collection.)

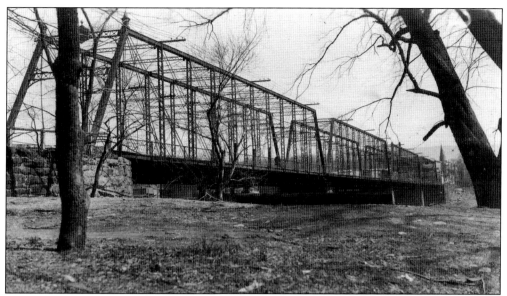

Shown here is the North Street Bridge, or if one was from Kingston, the Pierce Street Bridge. Until 1888 the only bridge crossing the Susquehanna in Wilkes-Barre was the Market Street Bridge. That bridge's board of directors opposed constructing another bridge across the river. So another board was created, and the bridge was built. It included an electric trolley line that traveled from Main Street to Wyoming Avenue, Kingston. There was a great deal of animosity between the members of the board of directors of each bridge. That ended in 1892 when the Market Street Bridge was closed for reconstruction and the North Street Bridge was then the only way to get across the river.

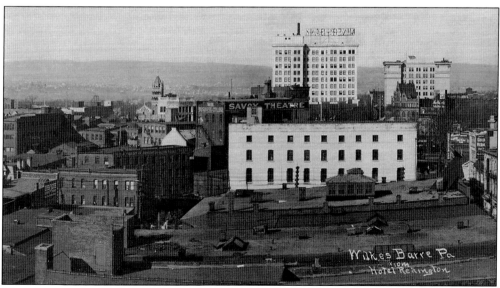

This photograph, dated April 4, 1927, offers an interesting look at downtown Wilkes-Barre. It was taken from the Hotel Redington, now the Genetti's complex, and it shows the top of the buildings from East Market Street. The Savoy Theatre is visible in the center. The note with this photograph reads, "first sound movies in Wilkes-Barre played at the old Savoy Theater."

23

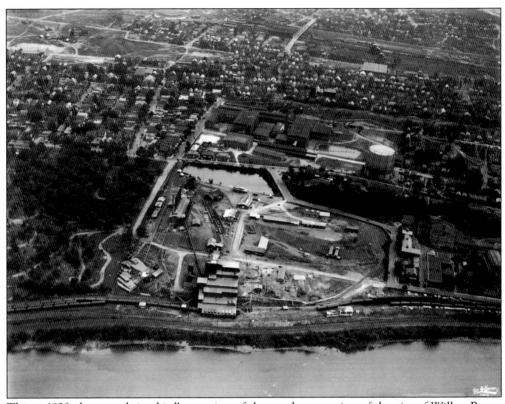

This c. 1929 photograph is a bird's-eye-view of the northern section of the city of Wilkes-Barre. Visible on the lower left of the photograph is a cemetery, possibly the Wilkes-Barre Cemetery, which is just south of the Hollenback Cemetery. The lace mill on Courtright Avenue is seen in the center of the photograph, and the Susquehanna River can be seen along the bottom.

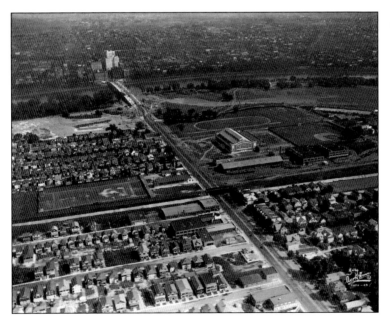

This photograph, taken in 1929 from above Kingston, shows the Market Street Bridge that crosses the Susquehanna River into the downtown area of the city. Taken well before the levees were built, the entire area encompassed by Kirby Park can be seen, perhaps even the zoo. Also visible is Nesbitt Park, located just across the street from Kirby Park.

This bird's-eye-view photograph shows the northernmost section of the city around 1929. In the foreground, the Hollenback Cemetery is visible. Just across River Street, the General Hospital can be seen. Because of development of the area around the hospital, this view is greatly changed today; some of the streets are gone and others have been rerouted.

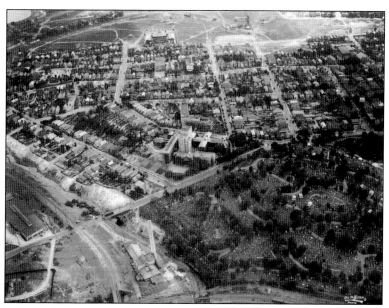

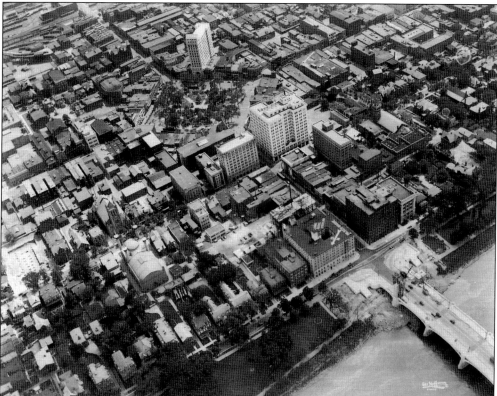

This c. 1929 bird's-eye-view photograph is of the city's downtown area. Public Square and the buildings that surrounded it are visible in the upper part of the photograph; the Market Street Bridge is in the foreground. Several landmark buildings are visible: the Hotel Sterling, which still stands; the Hollenback Coal Exchange; the Irem Temple; and the bank buildings along West Market and Franklin Streets.

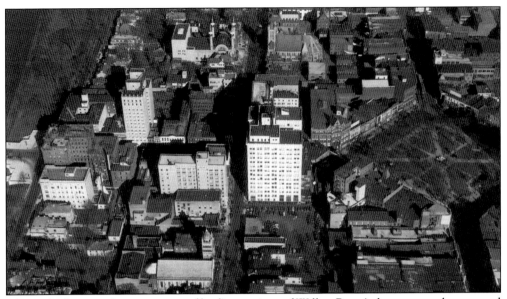

This is the first in a four-part series of bird's-eye views of Wilkes-Barre's downtown taken around 1930. This view is from above South Franklin Street, facing north. At left are the Market Street Bridge, Hotel Sterling, Coal Exchange, and Guard Buildings. In the center of the photograph, along Franklin Street, are the bank buildings, St. Stephen's Church, the Osterhout Free Library, and the Westmoreland Club. Public Square is visible at right in the photograph.

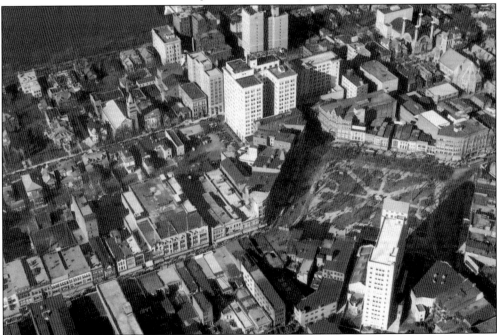

This west-facing photograph shows, at the top, the Susquehanna River and the buildings along River Street. The buildings along South Franklin Street can be clearly seen in this picture, including what is now the Bishop Library of the Luzerne County Historical Society. The retail stores along the western side of South Main Street are clearly visible as well. Public Square looks quite barren in this photograph.

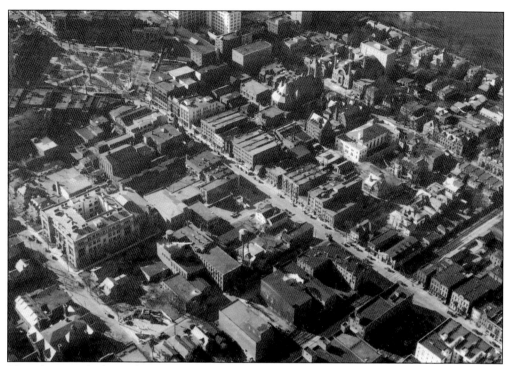

This photograph shows the area just north of Public Square in 1930. The square is visible in the upper left; the river can be seen in the upper right-hand corner. Across the center of the photograph is North Main Street and beyond that is North Franklin Street, where the Irem Temple is visible and the First Methodist Episcopal Church can be seen just across the street. At left, along North Washington Street, is Coughlin High School, the first of three city high schools.

The final photograph in this series was taken looking west from above present-day Pennsylvania Avenue. Coughlin High School is seen in the lower right; the square is on the left of the photograph. The buildings along North Main Street and the northwestern side of the square can be clearly seen here.

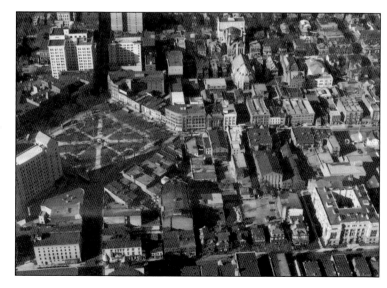

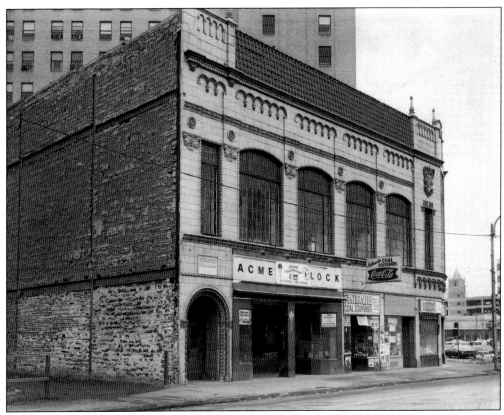

The building in this photograph, erected in 1930, is located on East Market Street. The stores shown here are Acme Lock, a locksmith, and Anthracite Coal Souvenirs. Above the retail shops was a dance hall, originally called the Orondo Ballroom and later the Stardust Ballroom, the sign of which can be seen above the door left of the Acme Lock sign. The last two names of the second-story establishments were the Naked Grape and the Crab Apple. The building was razed in 1978. In the background at right, it appears new buildings are being constructed along Public Square.

This c. 1931 aerial photograph shows downtown from a different angle, looking northeast into the city. Still visible is the Hollenback Coal Exchange building, Public Square, and the bank buildings; also visible is St. Stephen's Episcopal Church on South Franklin Street and the Stegmaier Brewery just at the upper edge.

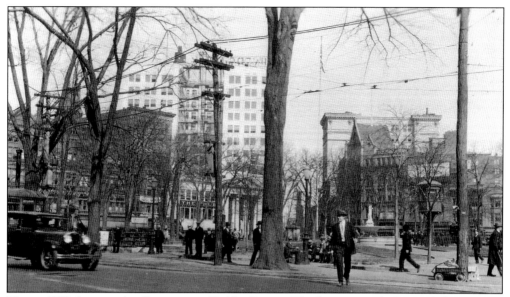

This c. 1935 photograph offers a view of Public Square. The fountain with the *Kankakee* statue is visible in the center of the square. The Hub, a clothing store, and the bank buildings along West Market Street, can be seen in the background. A year later, all of this would be under water from the flood of 1936, one of the worst that hit the Wyoming Valley.

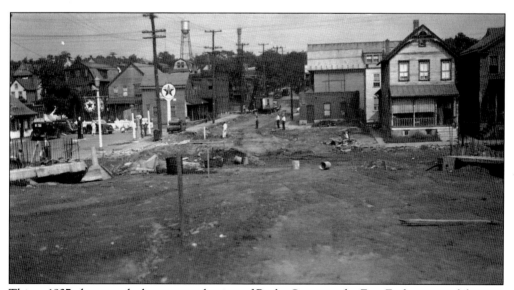

This c. 1937 photograph shows an early view of Butler Street in the East End section of the city. In this image, the Butler Street Bridge has not yet been constructed. This area certainly looks different today.

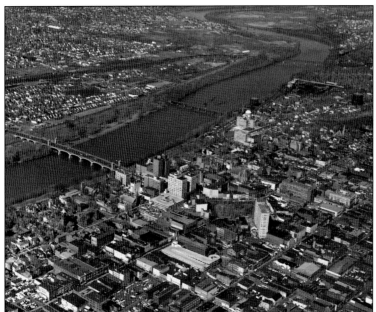

Here is a look at the city from above around 1950. Visible in this photograph are the Market Street, North Street, and Railroad Bridges on the Susquehanna River. The Hollenback Coal Exchange building is gone, but the Hotel Sterling seems to have enlarged. The Luzerne County Courthouse is visible near the North Street Bridge, and a breaker can be seen in the distance.

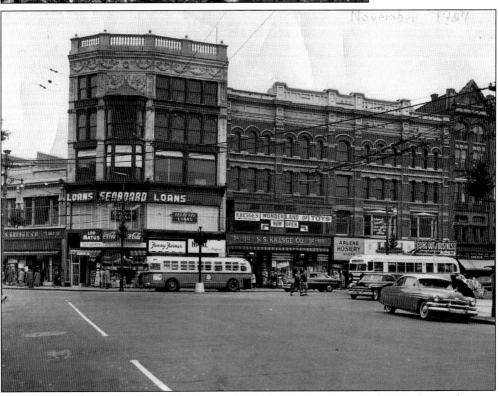

This photograph, taken of the southwestern side of Public Square around 1954, shows what was once a busy downtown. The shops lining that side of the square are well remembered and much loved and missed. Kresge Co., with its two entrances, was one of the first five-and-dime stores. Note the sign above the Public Square entrance advertising Kresge's Wonderland of Toys. Fanny Farmer sold candy.

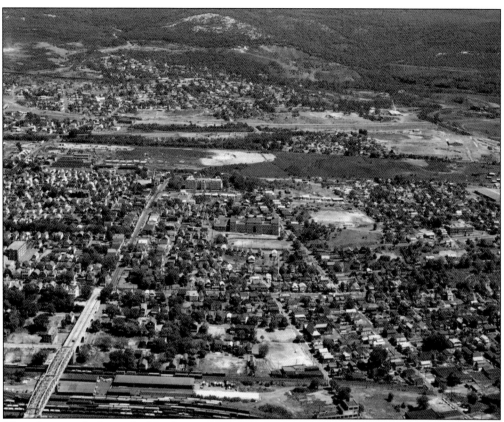

This photograph shows the Heights section of the city around 1960. The city expanded into the Heights in the 1860s, which is one reason the streets in that area are named for Civil War generals. Visible in the center of the photograph is GAR High School; north of GAR is the Mallinckrodt Convent. The South Street Bridge is visible in the lower left, and Wilkes-Barre Township, Laurel Run, and Giant's Despair are across the top of the photograph.

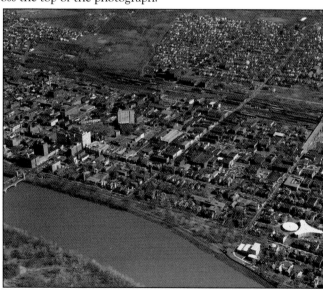

This c. 1967 photograph shows a growing city, expanded to the east. The growth of the campus of Wilkes College, now Wilkes University, can be seen as well, with many buildings added as enrollment increased. The two oddly shaped, light-colored buildings in the lower right of the photograph were used as the men's dorm and the dining hall. The railroad is still visible in the distance, running under the South Street Bridge. In the foreground, the river and a sliver of Kirby Park are visible.

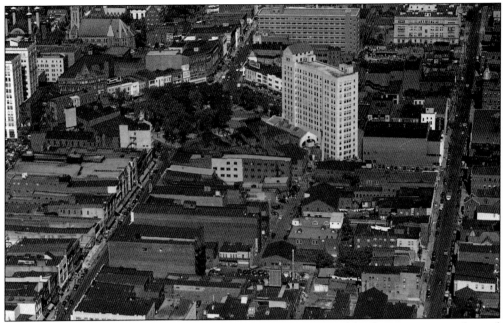

This aerial photograph taken sometime during the 1940s or 1950s of the downtown area is focused on Public Square and the area between South Main and South Washington Streets. City Hall can be seen along the right edge of the photograph, businesses around Public Square and down South Main Street can also be seen.

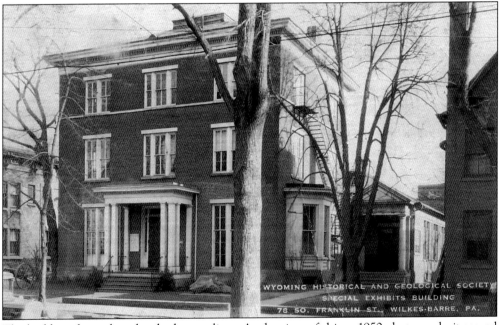

The building shown here has had many lives. At the time of this c. 1950 photograph, it served as the Wyoming Historical and Geological Society's Special Exhibits Building. The society purchased the building in 1926, first leasing it to the Presbyterian Church School, then to the Battle of Wyoming sesquicentennial committee in 1928. It housed the collections of what is now the Luzerne County Historical Society until the early 1950s.

This building is now the Luzerne County Historical Society's Museum, which houses both permanent and rotating exhibits as well as the Weathervane Gift Shop, offering books and memorabilia regarding the area's history. The building has been in continuous use as a museum since its construction in 1893. One permanent exhibit, located in the basement, is the replica of an anthracite coal mine; another exhibit, on the second floor, is dedicated to the history of Native Americans.

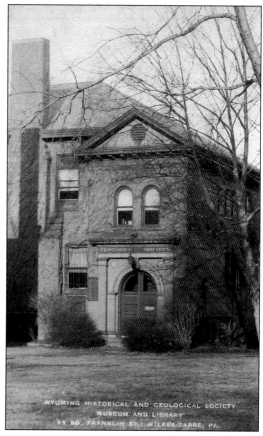

The Bishop Library, at 49 South Franklin Street, was purchased by the Historical Society in 1971 and named in honor of Elma C. and Bessie Bishop. Originally constructed in 1875, this building houses the paper collections of the society, along with old photographs, family histories, marriage and death records, and much more. The Luzerne County Historical Society is one of the oldest continuously operating local historical societies in America.

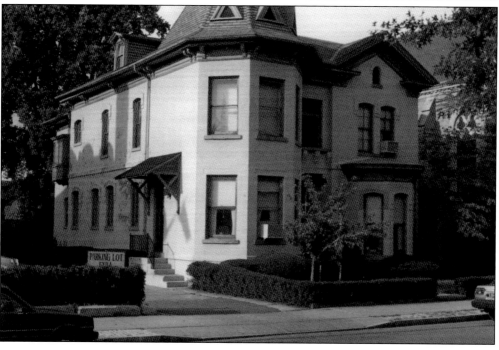

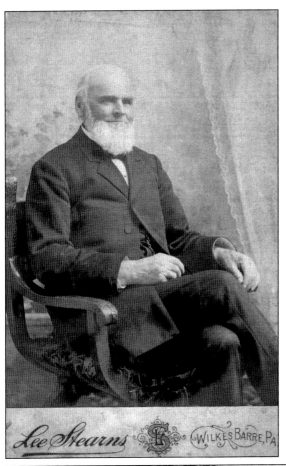

The community now known as Parsons was once known as Laurel Run, a station on the Lehigh and Susquehanna Railroad line in the mid-1800s. The name Laurel Run was already in use, so the town's name was changed to honor its most famous citizen, Capt. Calvin Parsons, shown in this photograph. As will be seen in the following images, the community had everything it needed within its borders.

This home, typical of those built in the 1800s, is identified in the photograph as being located in Parsons, Pennsylvania. The community of Parsons was not part of the city of Wilkes-Barre until its annexation, along with Miners Mills, in 1927.

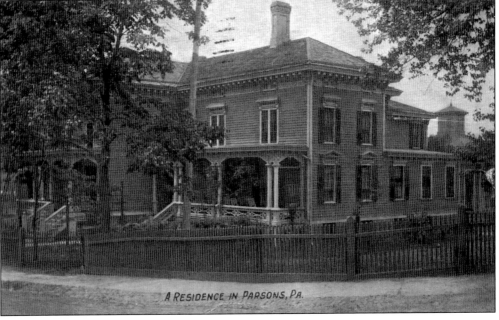

A RESIDENCE IN PARSONS, PA.

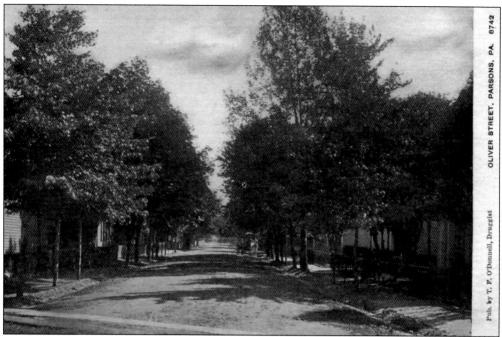

Oliver Street, pictured, is still visible on a map of Parsons. It runs between Scott and Govier Streets. Parsons was incorporated as a borough on January 17, 1876; it was formerly a village of Plains Township. The first settler, Daniel Downing, arrived in 1785 and built the first sawmill in 1800. In 1813, Hazekiah Parsons built a one-story house, the first frame house in the village. Parsons constructed a cloth dressing mill nearby and, in 1814, with J.P. Johnson, built a carding mill and a gristmill. Parsons became a milling center in the Wyoming Valley, and the population grew from just over 2,500 in 1900 to more than 5,000 in 1920.

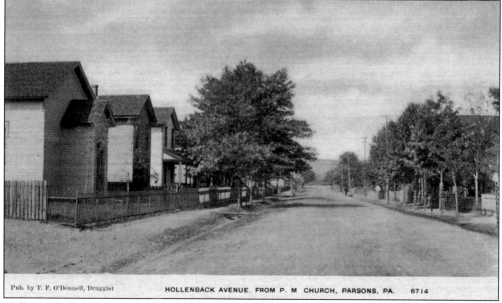

Hollenback Avenue, another road in the area named for the Hollenback family, is not found in the Parsons section. It is now located in the northern part of Wilkes-Barre.

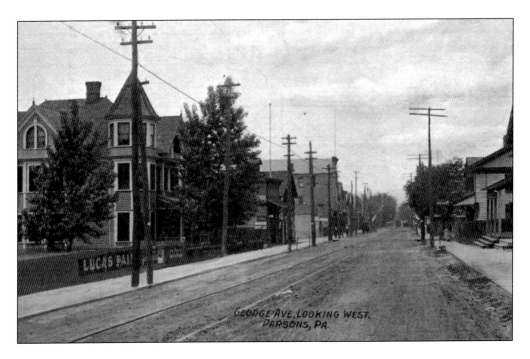

These two images show different views of George Avenue, one looking west (above), the other looking east (below). Today, George Avenue is a main thoroughfare in the area. It appears that it has always been a major road, evident by the appearance of trolley tracks and a railroad crossing in the center of each photograph. George Avenue was named to honor George Matson Hollenback, whose family owned much of the land.

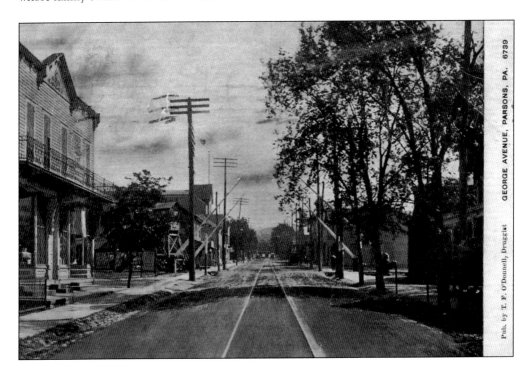

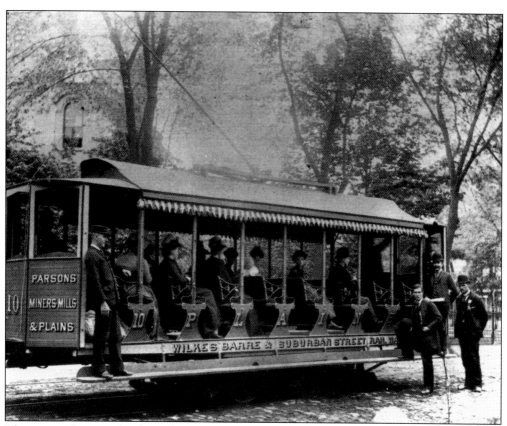

These two photographs show the streetcars, or trolleys, that connected the areas of Parsons, Miners Mills, and Plains to downtown Wilkes-Barre. The above image shows No. 10, one of the first open streetcars of the Wilkes-Barre & Suburban Street Railroad Line, waiting for passengers on Public Square, around 1896. The old courthouse is visible in the background. The photograph below shows No. 5, a closed streetcar, around 1920. It is interesting to note that the trolley in this photograph had space for advertising; to advertise a business on a streetcar, one had to call 2435 or stop by the Railroad Depot on Canal Street.

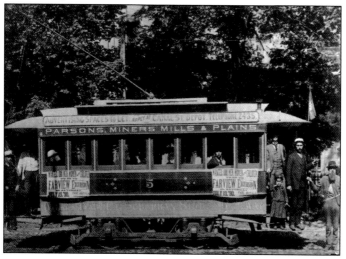

PARSONS PUBLIC SCHOOL, PARSONS, PA 6712

Parsons had its own schools, such as the high school shown here. There was also a grammar, or elementary, school in the neighborhood. The children who attended these schools walked to school—as the old-timers liked to say, they did so "uphill, both ways." In 1910, Calvin Elementary School was constructed in Parsons, educating students from kindergarten to sixth grade.

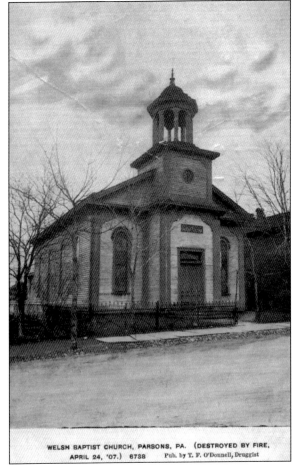

WELSH BAPTIST CHURCH, PARSONS, PA. (DESTROYED BY FIRE, APRIL 24, '07.) 6738 Pub. by T. F. O'Donnell, Druggist

As immigrants arrived and formed their own communities, they built their own churches, too. This one, the Welsh Baptist Church, was founded by immigrants from Wales who settled in the Parsons area. Having their own neighborhood church allowed the community to come together for services and special events.

The Independent Order of Odd Fellows (IOOF) is a fraternal organization inspired by the similar Odd Fellows service organizations in England. The IOOF was founded in the United States in Baltimore, Maryland. The order is still active but not in the valley. This photograph shows one of the many Odd Fellows halls in the area. There was one in just about every community.

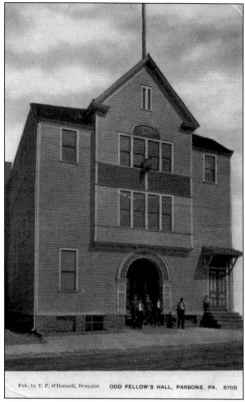

Pub. by T. F. O'Donnell, Druggist ODD FELLOW'S HALL, PARSONS, PA. 6709

This photograph shows a small part of Hollenback Park. In July 1907, John Welles Hollenback donated a tract of wooded land in the northern section of Wilkes-Barre to be used as a park and open space in perpetuity. Hollenback gave the city more adjacent land in 1908, bringing the total to 100 acres. In 1914, the city laid out a golf course on part of the land.

Possibilities, Hollenback Park.

39

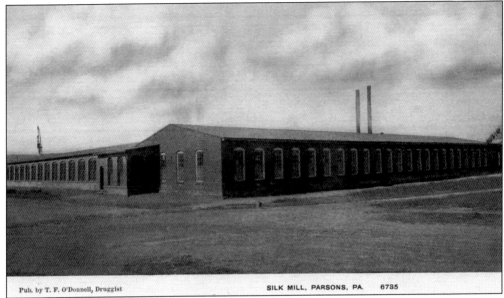

Pub. by T. F. O'Donnell, Druggist SILK MILL, PARSONS, PA. 6735

While the men worked in the coal mines, their sisters, wives, and daughters worked in the Wyoming Valley's successful textile industry. While not identified, the mill in this late 1890s photograph may be the Bamford Brothers Silk Manufacturing Company. The company was one of the largest silk ribbon manufacturers in the world, having two additional mills in New Jersey.

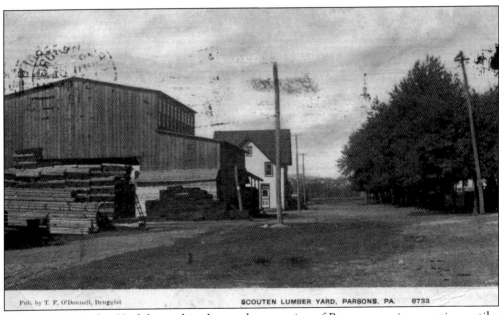

Pub. by T. F. O'Donnell, Druggist SCOUTEN LUMBER YARD, PARSONS, PA. 6733

The Scouten Lumber Yard, located in the northern section of Parsons, was in operation until a few years ago. It also went by the name of Scouten Lee and Company. Conrad Lee was one of the original owners. At the time of this photograph, the early 1900s, the company most likely sold timber to the railroads for their tracks. It also offered lumber to manufacturing companies to build their mills and factories.

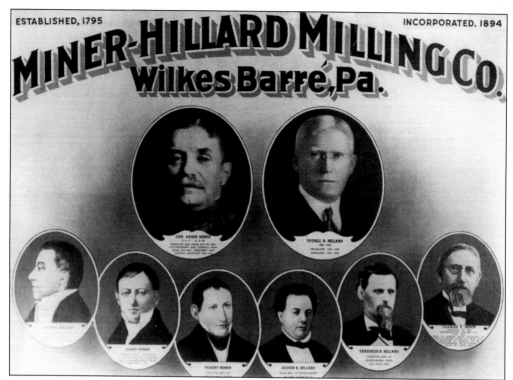

MINER-HILLARD MILLING CO.
Wilkes Barré, Pa.

Miners Mills, named for an actual mill owned by the Miner-Hillard Milling Company, had its beginnings in the late 1700s. As stated in this image of the company's leaders, the mill was established in 1795. The Miner-Hillard Company operated a total of five mills throughout the Wyoming Valley; two were in Miners Mills.

The history of Miners Mills is parallel to the history of the Miner family and of Charles A. Miner and Company Millers. In 1795, Thomas Wright came to the Wyoming Valley and built a mill. The milling business was passed first to Asher Miner and then from generation to generation of the Miner family. In the early 1900s, the mill was one of the leading flour milling companies. Miners Mills borough was chartered on December 12, 1883.

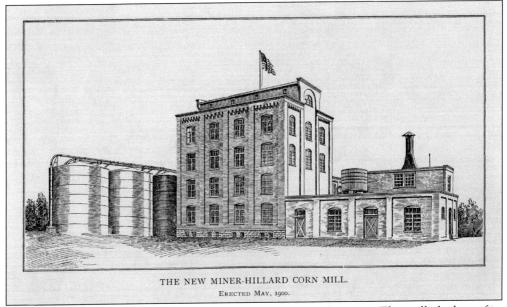

THE NEW MINER-HILLARD CORN MILL.
Erected May, 1900.

This line drawing illustrates the corn mill that was constructed in 1900. This mill, the best of its kind for its time, was equipped with machinery that was specially designed for the mill. On the left side of the image, three large iron tanks can be seen. These were built to store the grain, and each had a capacity of 20,000 bushels. This mill was fueled by anthracite culm. Culm is what is left over after the anthracite coal is removed.

The community of Miners Mills had its own churches and schools. Unfortunately, no photographs of the schools could be found. This image shows the Miner Congregational Church and Parsonage, identified as being in Plains, a frequent error, as the two communities shared a common border.

Two

SONS AND DAUGHTERS

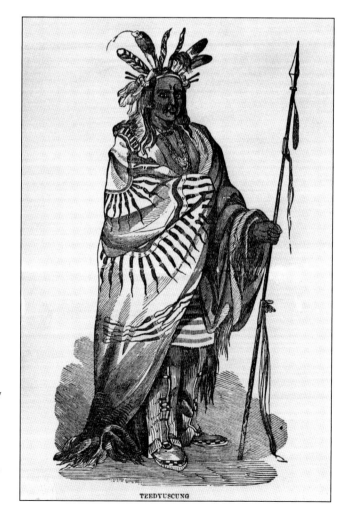

Self-described as "King of the Delawares," Teedyuscung tried to negotiate with the white men on behalf of his tribe, which already occupied an area of the city. This area was called Teedyuscung's Town and was located along the Susquehanna River in the southern section of what is now Wilkes-Barre. Teedyuscung had been successful in restoring his tribe's dignity and keeping the village from being destroyed. Unfortunately, on April 19, 1763, the King of the Delawares died in a fire.

TEEDYUSCUNG

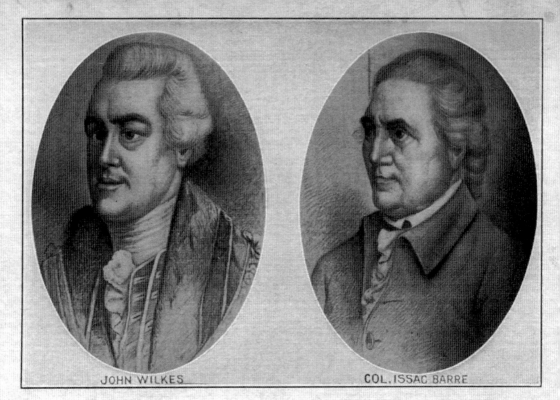

JOHN WILKES COL. ISSAC BARRE

PUBLISHED BY FOWLER, DICK & WALKER, WILKES-BARRE, PA.

This image shows John Wilkes (1725–1797) and Issac Barre (1726–1802), for whom the city was named. Wilkes was an interesting character, outspoken and at times downright rude and insulting. He was, however, a supporter of the colonies, which is why his name was selected for the city. Barre was a member of Parliament and a supporter of the colonists, and it was he who coined the term "Sons of Liberty" in reference to the colonists.

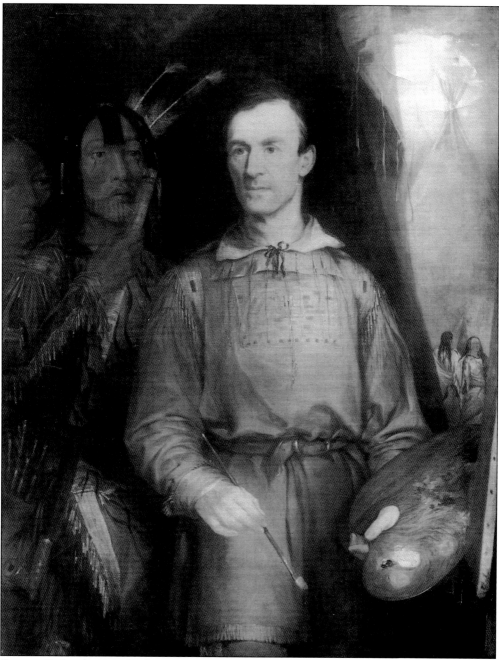

George Catlin, born in Wilkes-Barre in 1796, went on to become a famous painter of Native Americans, traveling with his subjects to achieve his results. His work was displayed in books he compiled, in galleries in London and Brussels, and in the Louvre in Paris. After his death in 1872, his wife donated his first Indian Gallery to the Smithsonian. These paintings, completed in the 1830s, are now part of the Smithsonian American Art Museum's collection. In addition, the American Museum of Natural History in New York City has over 700 of his sketches in its collection.

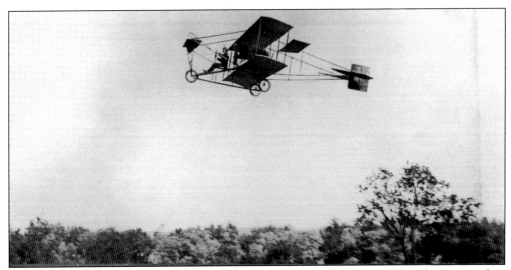

Lyman H. Howe (1856–1923), born in Wilkes-Barre, went on to become a self-taught moviemaker. Howe grew up with limited formal education, but he learned through trial and error that the public just wanted to be entertained. In 1890, he discovered the phonograph and used it to entertain the public with recordings of concerts and lectures. Eventually, his genius led him to moviemaking, debuting his first show in Wilkes-Barre in 1896. Soon after, he had his own film company, which grew to six different traveling companies based in the city. These companies traveled around, showing Howe-created films of presidents, important events, and even European royalty. Howe is pictured above piloting the plane.

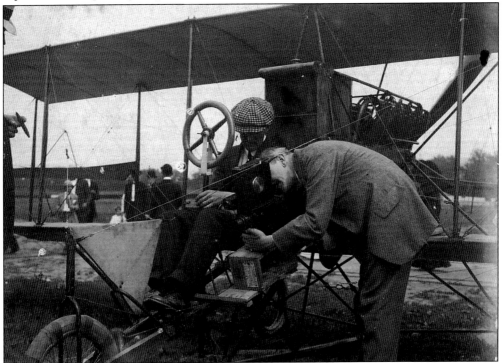

This c. 1911 photograph shows Howe's assistant, Lincoln Beachey preparing to take off to film from a plane. His cameraman is adjusting the camera that will take the aerial shots.

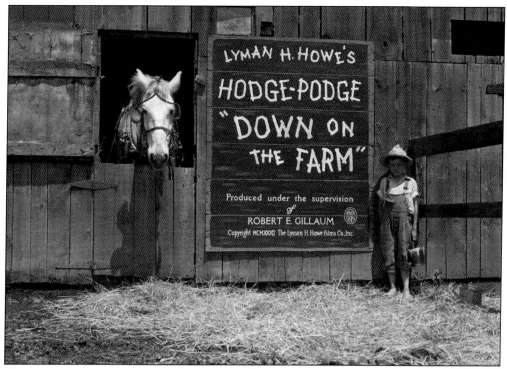

These images are cinema posters from two of Howe's many films. Howe also produced films of the Olympic games, the wedding of King Alphonse of Spain, and Pres. Theodore Roosevelt's visit to Wilkes-Barre.

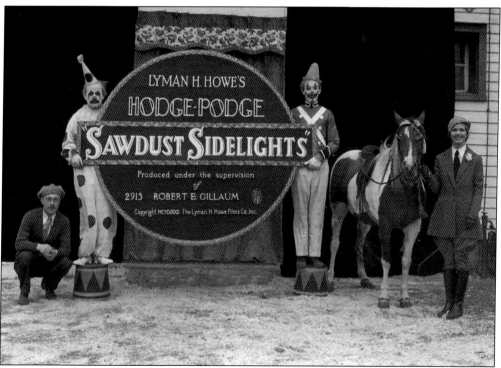

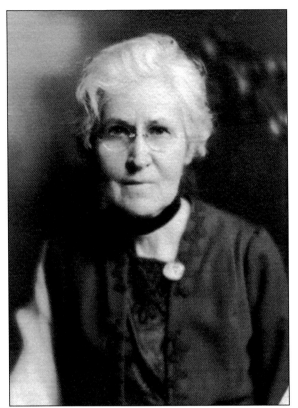

Edith Brower (1848–1931) organized what eventually became the Wyoming Valley Women's Club. It was through this club that Brower became an activist in Wilkes-Barre, assuming responsibility for a major beautification project. One of her lectures, given at the Historical Society, was turned into a book, *Little Old Wilkes-Barre as I Knew It.* This tale was about her memories of the city before and during the American Civil War.

Ellen Webster Palmer (1839–1918) was born in Plattsburg, New York, and came to Wilkes-Barre after marrying Henry W. Palmer. Ellen was known for her work with the "Breaker Boys" of the valley. Her work with the boys began in 1891, when she started a series of meetings that eventually led to the establishment of the Boys' Industrial Association. Palmer held classes in reading, writing, and arithmetic, helping hundreds of boys get out of the mines and into schools and better jobs.

John J. Curran, the first pastor of Holy Saviour Church in the Five Points section of Wilkes-Barre, is regarded as one of the most active priests, and one of the most loved, in the city's history. As a boy, Curran worked in the mines, giving him something in common with his parishioners. He worked to establish College Misericordia and St. Patrick's Catholic Church and advocated the construction of a wing of the Mercy Hospital. He was a strong supporter of the Cause and Rights Bill of the miners. During the great anthracite strike of 1902, Curran befriended John Mitchell of the United Mine Workers of America and Pres. Theodore Roosevelt; together, they worked to create a better occupational environment for those who worked in the mines. Shown in the c. 1930 photograph below are John L. Lewis (left, United Mine Workers of America), Thomas Kennedy (center, Hazleton UMW), and Curran.

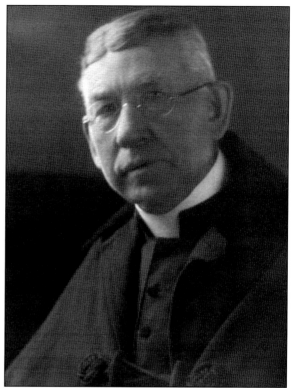

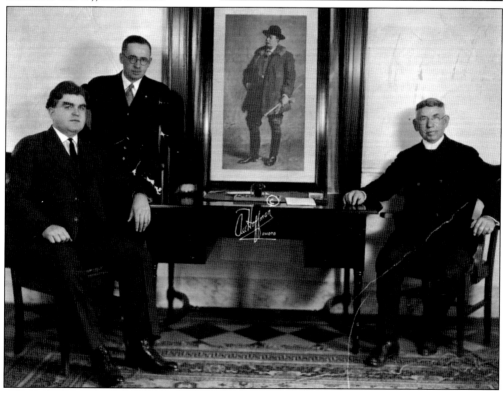

Fr. Joseph Murgas came to the valley as an accomplished painter, a brilliant naturalist, a talented linguist and writer, and a devoted Slovak patriot. He made his major contribution in the field of radio communication. He developed a way to send two or more sounds for distances of 70 miles over land and 700 miles over water, therefore accommodating Morse code. Marconi's process could only send a single sound, only over water, and only for short distances. In 1903, Murgas founded a company to test and develop his discovery, eventually earning a patent for his inventions. In 1916, the US District Court recognized Murgas as the inventor of practical wireless communication.

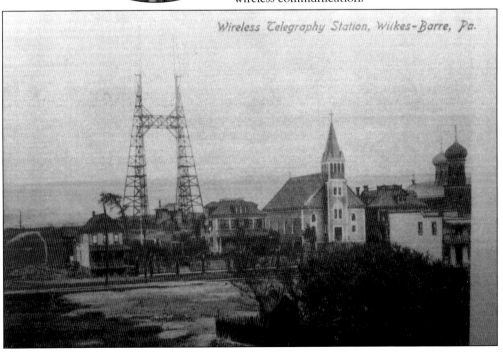

Wireless Telegraphy Station, Wilkes-Barre, Pa.

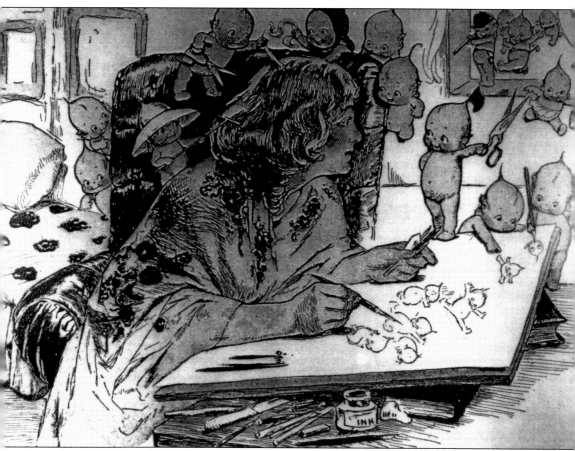

This drawing of Rose O'Neill was composed by the artist herself. O'Neill was born in Wilkes-Barre in 1874, and her career began at age 13, when she won an art contest and was hired by the sponsoring newspaper to do a weekly cartoon. O'Neill created her first Kewpie illustration for the December 1909 issue of the *Ladies Home Journal.* Kewpie means "small cupid." As O'Neill stated, "they are wigglesome and disposed to hop out on the balcony to play with the birds." Soon, Kewpie dolls of varying sizes were everywhere, and their likeness appeared on calendars, greeting cards, mugs, plates, lamps, jewelry, and much more.

Charles Edgar Patience (1906–1972) learned the art of sculpting from his father. However, his art went further than the simple souvenirs his father created. Patience created beautiful works of art that now are housed in museums and, as seen below, in King's College Chapel of "Christ the King." Other pieces of his art include a Hoover vacuum, a Mack Bulldog, and a bust of Pres. John F. Kennedy. His work has been displayed in Canada and in the Smithsonian in Washington, DC. Each piece of art designed and created by Patience was one of a kind. The altar (below) was made from a single block of anthracite coal weighing more than 4,000 pounds. Patience died on June 7, 1972, at the age of 65, from pneumonia brought on by many years of breathing in coal dust.

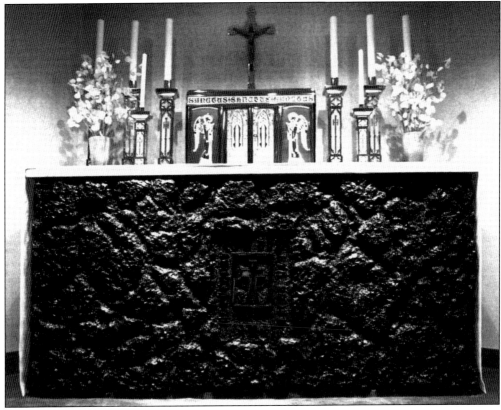

Three

HOW THEY LEARNED

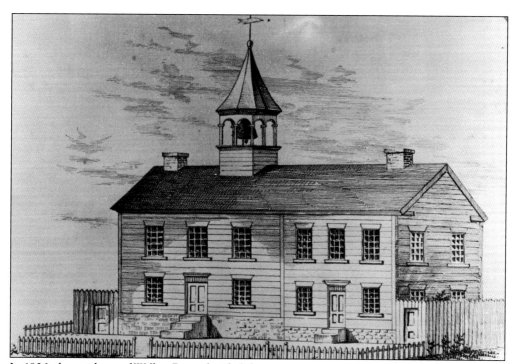

In 1806, the residents of Wilkes-Barre decided that improvements were needed to school facilities, as their children were being educated at home at only elementary levels. In May 1807, a new semi-public school, for the education of youth in arts, sciences, and literature was established. This school, the Wilkes-Barre Academy, is seen in this c. 1807 image.

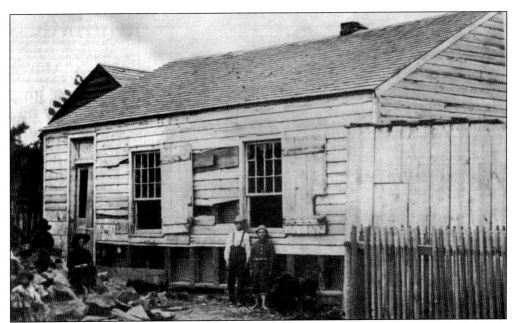

In this c. 1864 photograph is the Cinder Alley School, one of three schoolhouses in the borough at the time. It was a wooden one-room schoolhouse with just enough space for desks and a heating source, usually a wood stove. Grammar and history were taught at schools such as this one. This school was atypical of other borough schools, as it was constructed in the poorest part of town, along the railroad yards.

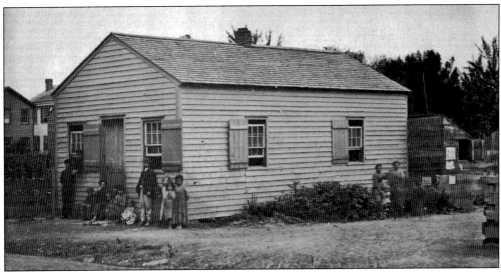

Another of the one-room schoolhouses in the borough in 1864, this one appears to be in better shape than the school in the previous photograph. This one was located on North Washington and Bennett Streets.

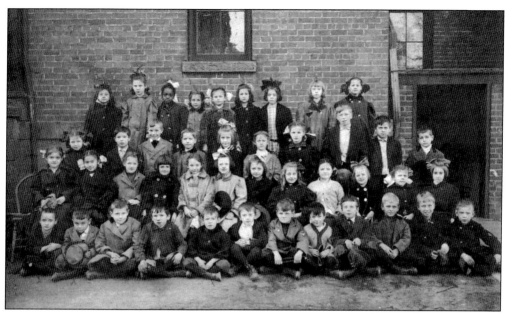

Shown in this undated photograph is a group of schoolchildren outside their school in Wilkes-Barre. This is perhaps a class photograph.

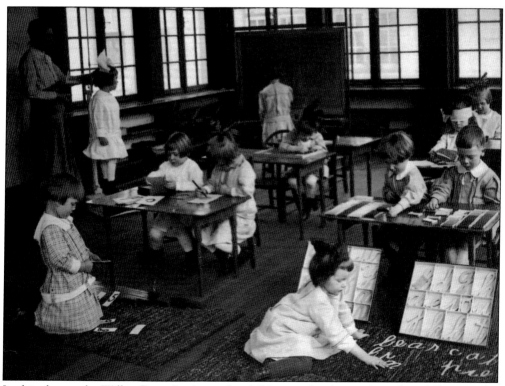

In this class at the Wilkes-Barre Institute, the children are hard at work, each at different tasks. The teacher is at left. Note the child at right wearing some sort of bandage around her head.

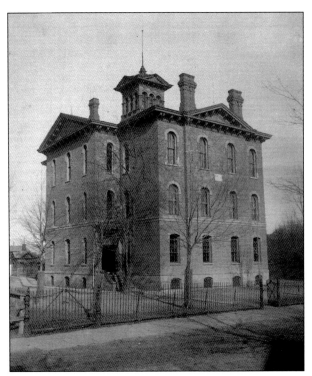

The Franklin Street School is one of the few buildings still standing from the early days of public education in Wilkes-Barre. The school was built in 1912 to accommodate elementary students up to the sixth grade—quite an improvement from those one-room buildings.

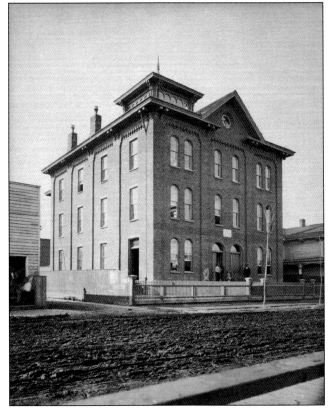

Shown here is a similarly designed but unidentified school building, noted to have been located on Washington Street. Prior to the consolidation of the Wilkes-Barre School District, every neighborhood in the borough had an elementary school building, and the children all walked to school. These schools were generally named for the streets on which they were located.

This photograph of another neighborhood school, Meade Street School, was taken after the school was closed. It was located in the Heights section of the city on Meade Street.

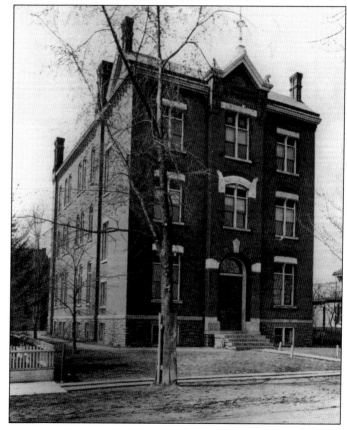

The Hillman Academy, shown here, was located on the corner of West River and Terrace Streets. The three-story building's interior was designed from sketches made by teachers, with spacious rooms and wide hallways. H. Baker Hillman erected the building as a memorial to his son, Harry G. Hillman, who died in 1886, at the age of 20.

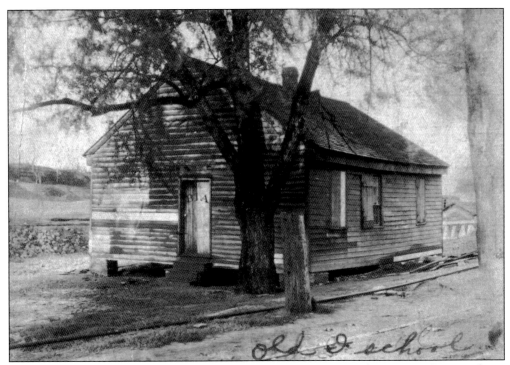

This c. 1899 photograph shows an early Boys Industrial Association building, where Ellen Webster Palmer worked with the breaker boys. Palmer taught the boys lessons in reading, writing, and arithmetic as a way to help them improve their lives.

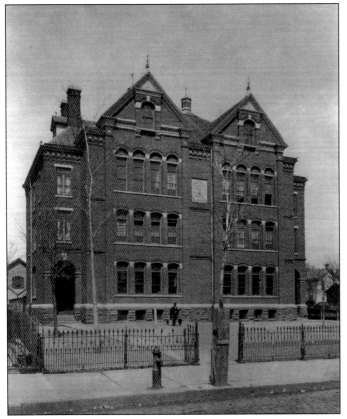

This building, Central High School, was the first public high school in Wilkes-Barre. It quickly became overcrowded.

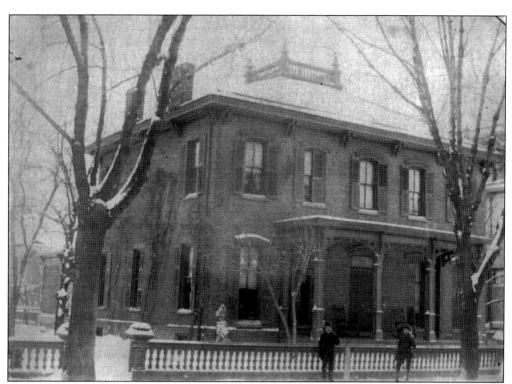

The Girls Institute was located in this building, at 78 South Franklin Street, beginning in 1881. Prior to being housed in this building, the female students had two rooms in the Wilkes-Barre Academy building on Public Square. The Girls Institute eventually became part of Wyoming Seminary.

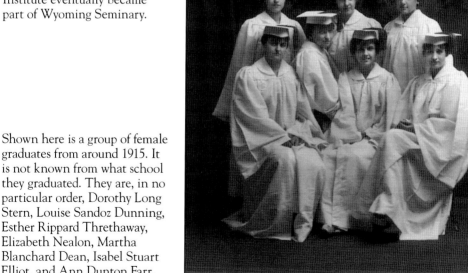

Shown here is a group of female graduates from around 1915. It is not known from what school they graduated. They are, in no particular order, Dorothy Long Stern, Louise Sandoz Dunning, Esther Rippard Threthaway, Elizabeth Nealon, Martha Blanchard Dean, Isabel Stuart Elliot, and Ann Dunton Farr.

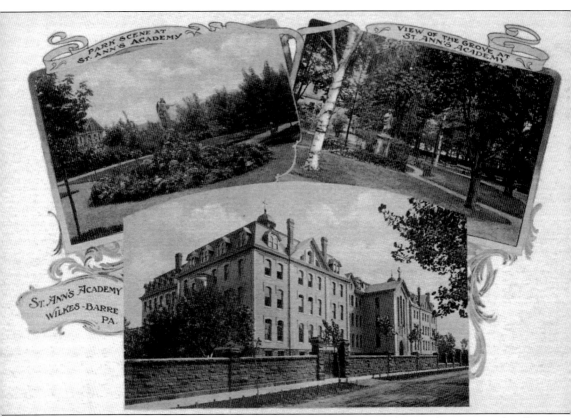

St. Ann's Academy was housed in the Mallinckrodt Convent, in the Heights section of Wilkes-Barre. It opened with six students on November 4, 1878. St. Ann's was established by Mother Pauline von Mallinckrodt as a female academy for girls who were religious and moral. The girls who studied here went on to become successful women, getting higher degrees in law, education, and science. They became doctors, missionaries, artists, teachers, lawyers, and much more. St. Ann's closed in June 1971, and in September of that year, the students attended the new Bishop Hoban Central Catholic High School, now Holy Redeemer.

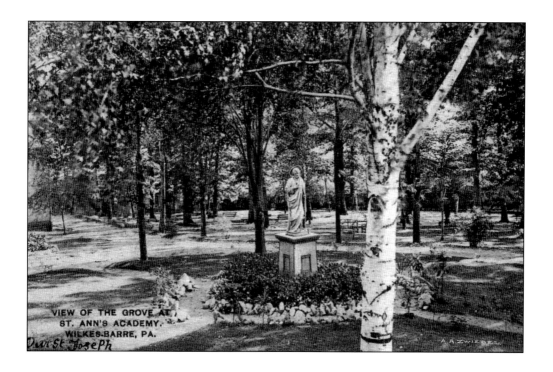

VIEW OF THE GROVE AT
ST. ANN'S ACADEMY.
WILKES-BARRE, PA.

The students attending St. Ann's Academy lived on the campus in its beautiful, park-like setting. Shown here are two views of the lovely, calming groves.

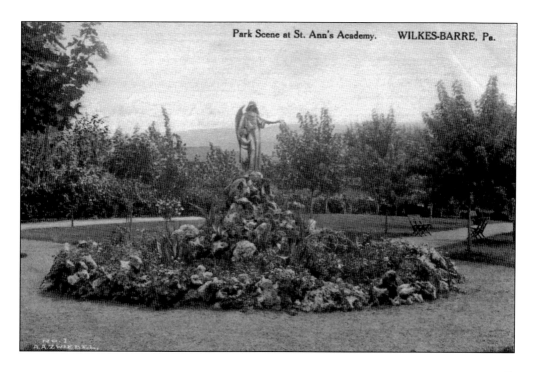

Park Scene at St. Ann's Academy. WILKES-BARRE, Pa.

61

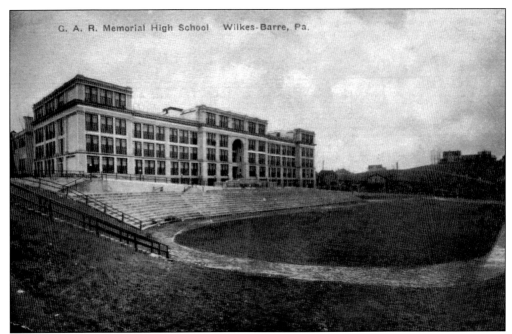

The Wilkes-Barre School District, after the nearly immediate overcrowding situation at Central High School, ascertained the need for more space for upper-level students. Coughlin High School, built on the first block of North Washington Street, was the first high school, welcoming its initial class in 1911. The second high school in the district was GAR High School (above), built in the Heights section of the city in 1925. The third secondary school came in 1930. Elmer L. Meyers High School (below) was located on Carey Avenue in the southern section of the city. All three school buildings are still standing and still in use; however, after years of floods, the future of Meyers High School is uncertain.

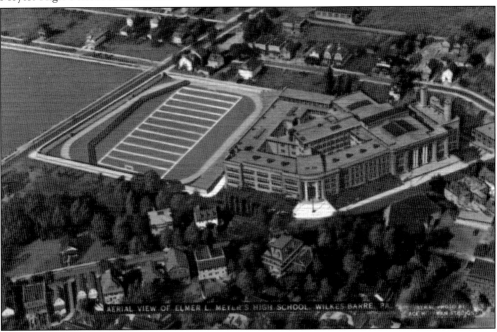

AERIAL VIEW OF ELMER L. MEYERS HIGH SCHOOL, WILKES-BARRE, PA.

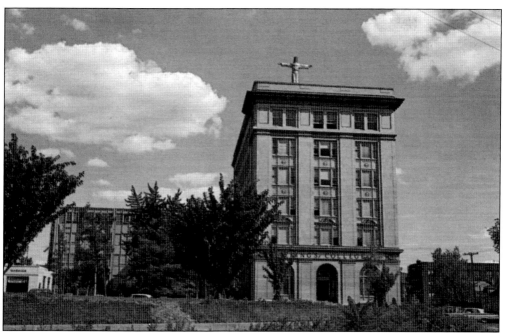

King's College was founded in 1946 by the Congregation of Holy Cross from the University of Notre Dame. The college was initially built to educate the sons of local miners and millworkers. The administration building, above, was built in 1913, before the college even existed. Close by, on the corner of South Franklin and East Jackson Streets, the college's Chapel of "Christ the King" houses a 4,200-pound anthracite altar that symbolizes the relationship between the coal industry and the college. It was created for King's in 1954 by C. Edgar Patience. The campus covers the areas between North River and North Washington Streets and between East Union and East North Streets. The college offers bachelor's degrees in 35 majors, including business, education, humanities, sciences, social sciences, and allied health programs, and a master's degree in physician's assistant and education studies.

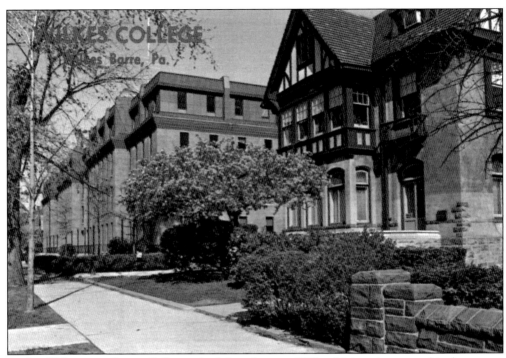

Bucknell University Junior College, which later became Wilkes University, opened in downtown Wilkes-Barre in September 1933. The school was established as a result of a statewide study that showed the need for junior colleges in urban areas. The school began in Wilkes-Barre without money or public support; the first classes were held on the third floor of the Wilkes-Barre Business College, on West Northampton Street. The following year, the business college moved out and the junior college took over the building. Over the years, the college would take possession of the old mansions along South River and South Franklin Streets, using them for student housing, administrative offices, and classrooms. In 1947, the junior college became Wilkes College, as the need for a four-year institution of higher learning became apparent. It became Wilkes University in December 1989 after the college was restructured.

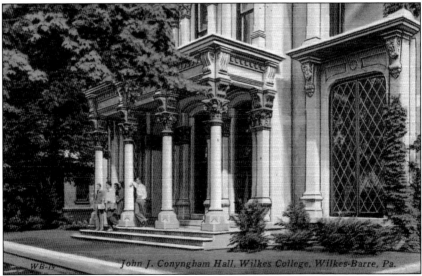

John J. Conyngham Hall, Wilkes College, Wilkes-Barre, Pa.

Four

CLUBS AND ENTERTAINMENT

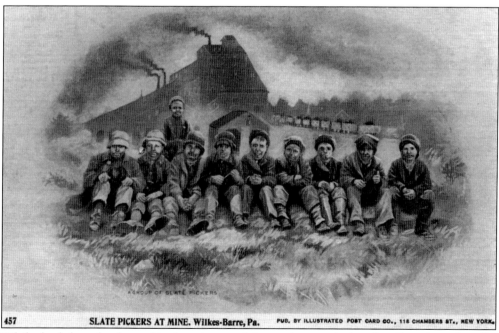

457 SLATE PICKERS AT MINE. Wilkes-Barre, Pa. PUB. BY ILLUSTRATED POST CARD CO., 116 CHAMBERS ST., NEW YORK.

While the fathers dug for coal in the mines, and the mothers worked in the silk and textile mills, the children were put to work picking the coal and separating it into sizes in the breaker. Many of these breaker boys were injured or killed by falling coal. Some lost fingers, hands, arms, all for pennies a day, if that. Fortunately, children of the 19th and early 20th centuries did not all have it this bad, as the following images will show.

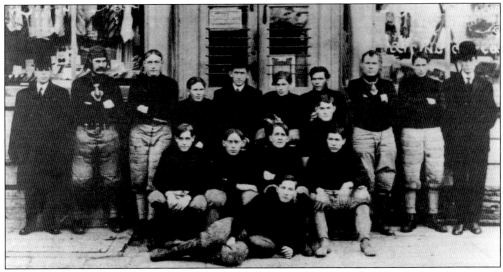

Athletic clubs were popular in the 1800s. According to information found with this photograph at the Luzerne County Historical Society, shown here are the members of a Cheese and Crackers Club in 1867. It is evident they are preparing for an early game of American football.

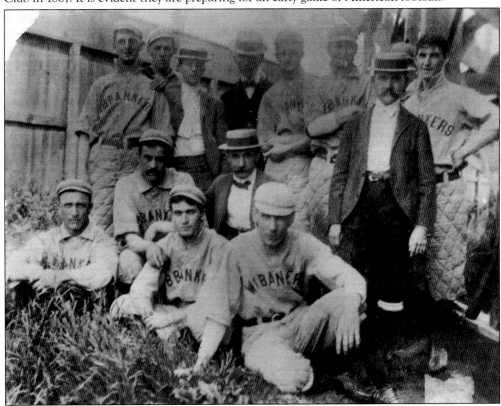

Seen here, around 1900, is the Wilkes-Barre Bankers, one of several semiprofessional teams from the city. On October 12, 1926, Babe Ruth visited the city and played baseball in Artillery Park, now part of Kirby Park. During the game, Ruth hit a ball that traveled over 600 feet, setting a record in baseball history. In April 2012, a plaque was installed in Kirby Park where the ball landed.

Shown here are the members of the Crackers & Cheese Club around 1867. It is not known how or why they named the club as they did. The members shown here are, from left to right, (seated) Charles Parrish, Edward Payson Darling, Henry Martyn Hoyt, and Stanley Woodward; (standing) Winthrop Welles Ketcham, John Case Phelps, Andrew Todd McClintock, Garrick Mallery Harding, Washington Lee, John Henry Swoyer, Thomas Henry Atherton, and William Lord Conyngham.

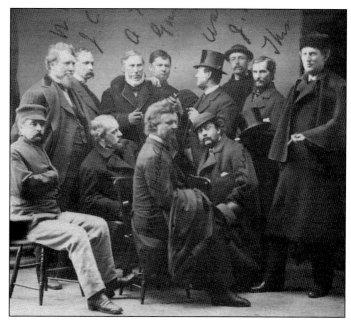

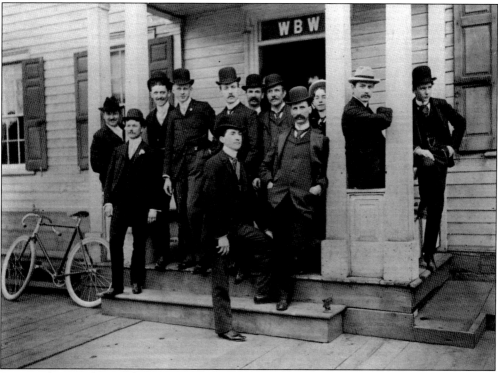

Seen in this April 1898 photograph are members of the Wilkes-Barre Wheelman Club in front of their clubhouse, the Pickering House, on South Main Street. Pictured in no particular order are Harry Garrison, Grant A.C. Behee, Erskine L. Solomon, Richard DeWitt, Frank Brown, John Evans, William Turner, J. Lewis Behee, Richard Turner, Guy DeWitt, and Arthur MacDonald. The Wheelman Club later built another clubhouse on South Franklin Street, a building that remains standing today.

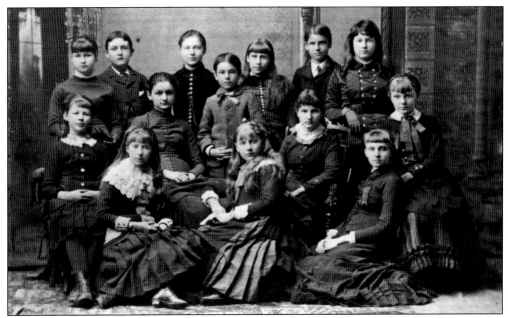

The Agassiz Association was a natural history club for children in the 1880s, named for naturalist Louis Agassiz. Harrison Wright, a local attorney and active member of the Wyoming Historical and Geological Society, organized the club, which he sponsored until his death. The members in the photograph are, from left to right, as follows: (first row) Ellen C. Palmer, Elizabeth North, and Ethel Hosmer; (second row) Jessica D., Effie Parsons, Clare Hillman, and Eleanor Hollenback; (third row) Hortense Beaumont, Edgar Reets, Grace Derr, Arthur H., Grace Rockafeller, Ralph Hillman, Helen Reynolds.

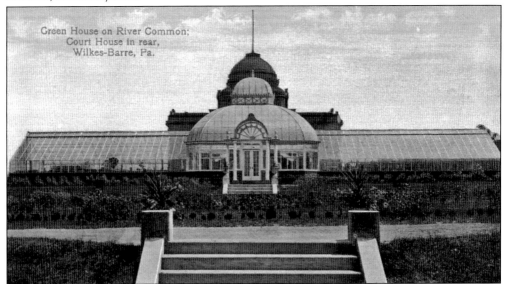

This beautiful location would have been a great place for the Agassiz Association to study natural history. The greenhouse was built, however, after the group disbanded. It was nevertheless a wonderful place to study horticulture. In fact, it was used to educate schoolchildren in the 1920s and early 1930s. When the conservatory was actively used, the city parks were adorned with flowers and plants that were grown there.

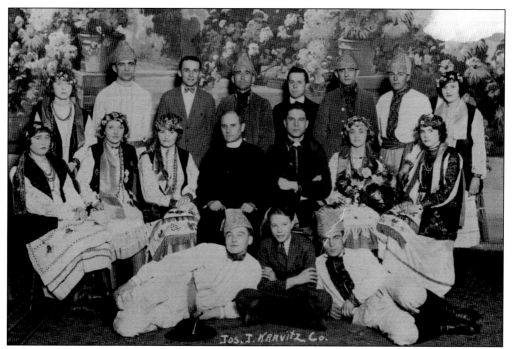

This group is the Lithuanian Dancing Club. Each ethnic group brought its own customs and cultures from the home country. This is an example of such a custom. Members are dressed in traditional garb for the ceremony they are about to present.

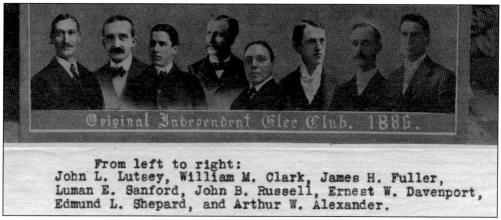

From left to right:
John L. Lutsey, William M. Clark, James H. Fuller, Luman E. Sanford, John B. Russell, Ernest W. Davenport, Edmund L. Shepard, and Arthur W. Alexander.

This photograph is fairly self-explanatory, showing members of the Original Independent Glee Club in 1886. Certainly, they are not children, but are young men in perhaps their early 20s.

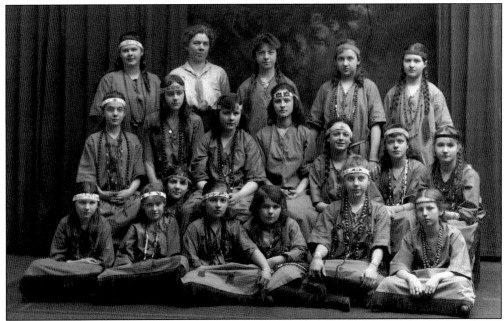

This c. 1890 photograph shows members of the Susquehanna Camp Fire Girls, who appear to be dressed in Native American garb, according to information obtained at the Luzerne County Historical Society. Research shows that Camp Fire Girls was not formally organized until 1910.

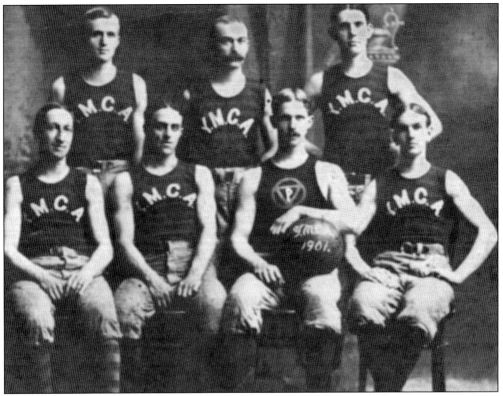

Shown in this photograph are the members of the 1901 YMCA basketball team.

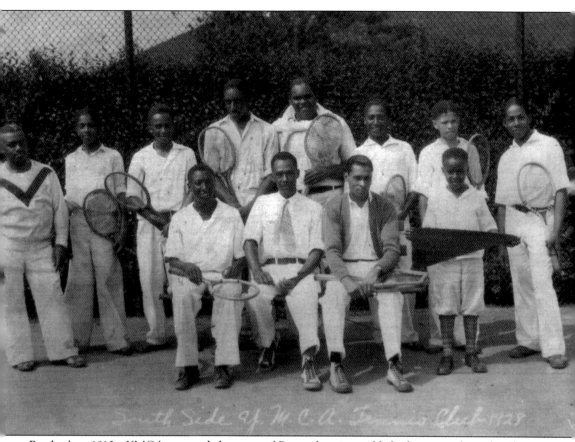

South Side of Y.M.C.A. Tennis Club 1928

By the late 1910s, YMCAs around the state of Pennsylvania established separate branches for young men of color. In March 1922, the black citizens decided to do the same in Wilkes-Barre. They initially adopted the name Colored Young Men's Christian and Industrial Association; this became known as the South Side Branch of the YMCA and was located on South Main Street. In addition to tennis, members could participate in crafts, ping pong, billiards, table games, reading, and dances. In this photograph from around 1928, the members are, from left to right, as follows: (first row) George Hillman, Aaron Green, Ned Brown, and Carl Green; (second row) Bob Patience, Harold Patience, Lawrence Moss, Fred Dwyer, Wesley Bunch, Chris Hillman, Olin Morris, and Clarence Fisher. The South Side YMCA closed its doors in 1960.

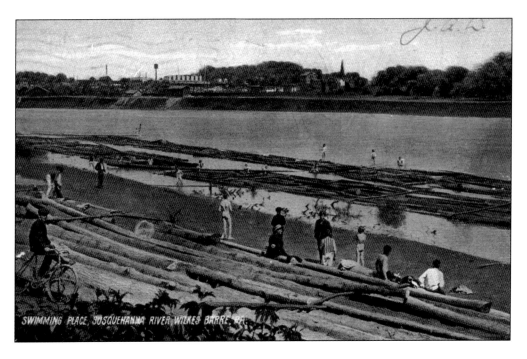

SWIMMING PLACE, SUSQUEHANNA RIVER, WILKES BARRE, PA.

These two images show what cannot be done today—swimming in the Susquehanna River. The currents are too strong and the river is too deep to allow swimming now. Additionally, the river is no longer as clean in the area as it once was. The above photograph is from sometime in the early 1900s, but after 1909, when the courthouse was completed. What is most interesting is the attire of some of the bathers; at least one of them appears to be missing a suit! The photograph below shows an interesting group of people also swimming in the river. The scene is noted as being in Wilkes-Barre, but no landmarks can be identified by the author.

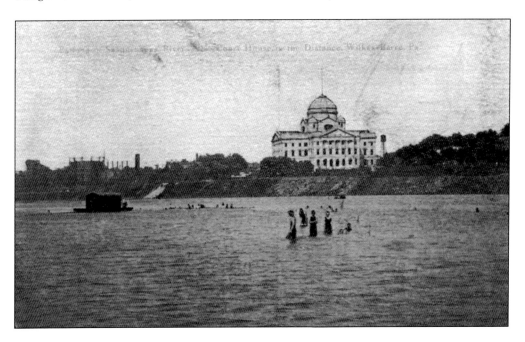

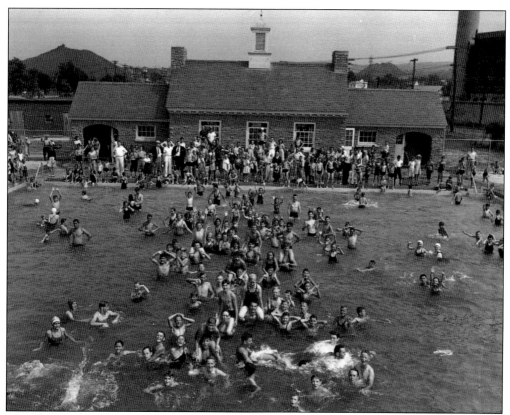

This photograph shows people enjoying one of the two public swimming pools in Wilkes-Barre. At the time this photograph was taken, around 1950, the city had 23 public parks, but only 2 had pools. Before 1949, any area resident could use the pools; in 1949, the policy was changed, allowing only city residents to use the pools. This photograph is of the Hollenback Pool in the Parsons section of the city.

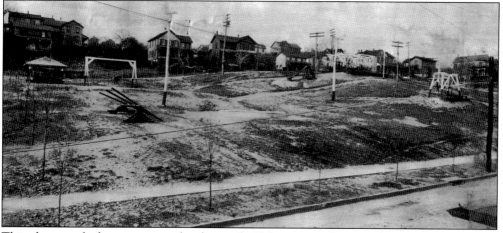

This photograph shows an example of an early-20th-century playground in Wilkes-Barre. The playground includes wooden teeter-totters, sliding boards, and swings. The specific neighborhood is unidentified. This c. 1905 photograph appears to have been taken in the winter, since there seems to be snow on the ground and the trees are missing their leaves.

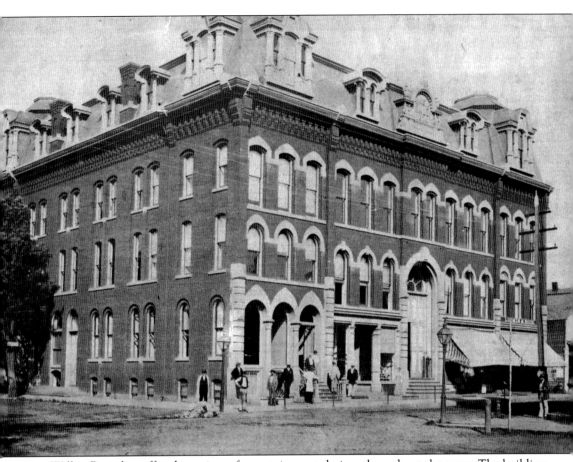

Wilkes-Barre has offered a variety of entertainment choices throughout the years. The building in this 1885 photograph is on the corner of West Market and North River Streets. Called the Music Hall, many varied musical groups performed here. This structure was built by Isaac Perry in 1871 and was demolished in 1896, to be replaced by the Hotel Sterling.

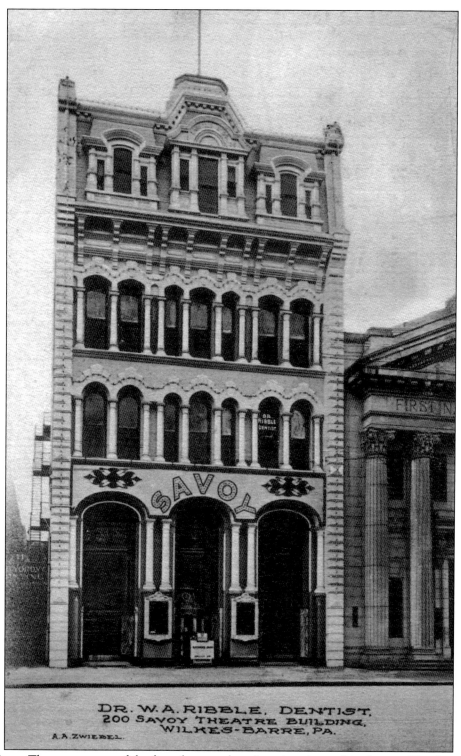

DR. W.A. RIBBLE, DENTIST,
200 SAVOY THEATRE BUILDING,
WILKES-BARRE, PA.

A.A.ZWIEBEL.

The Savoy Theatre was one of the first places to show "moving pictures" in the city. The Savoy was located on Public Square in downtown Wilkes-Barre.

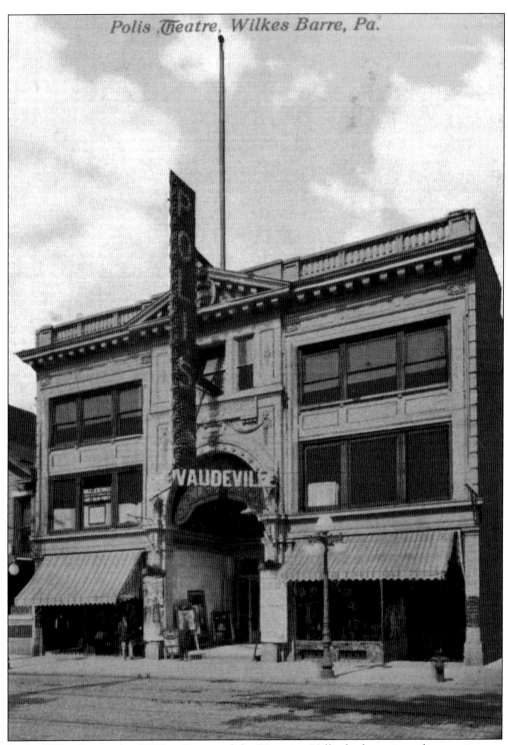

Polis Theatre, Wilkes Barre, Pa.

In the 1920s, the people of Wilkes-Barre and the Wyoming Valley had a variety of entertainment choices. Vaudeville groups came to town to perform at theaters such as Poli's, Orpheum, and Capital before going to New York to perform. Poli's Theatre was located on South Main Street.

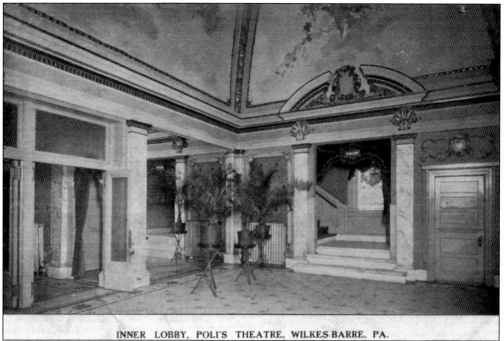

INNER LOBBY, POLI'S THEATRE, WILKES-BARRE, PA.

What a grand-looking place Poli's was! High ceilings, marble columns, potted plants, and ornate trim gave the place the look of a theater on Broadway, instead of one in a little town like Wilkes-Barre.

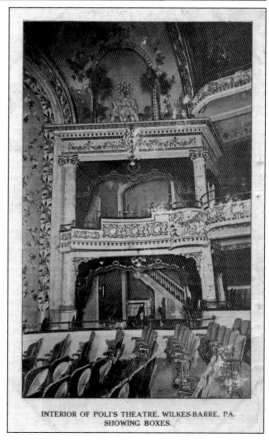

INTERIOR OF POLI'S THEATRE, WILKES-BARRE, PA.
SHOWING BOXES.

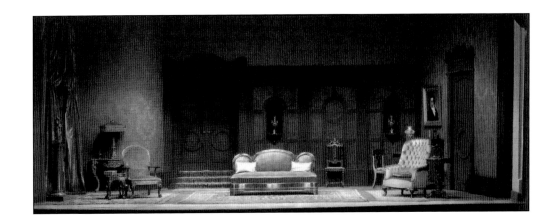

The Little Theatre of Wilkes-Barre, organized in 1922, is the third-oldest continuously running community theater in the United States. Initially without a permanent home, its first season was performed in the building that is currently Coughlin High School. The theater moved into its current home at 537 North Main Street in 1957. From its first performance, Kipling's *The Elephant's Child*, to today's performances that rival off-Broadway or even Broadway shows, the Little Theatre and its performers have exhibited excellence in quality programs. The two sets shown in these photographs are from the 1960 season.

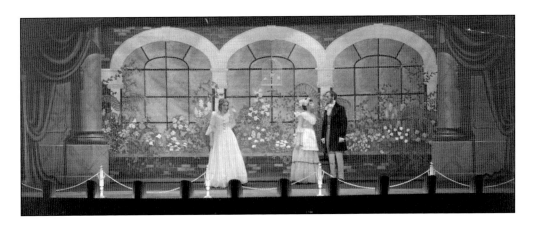

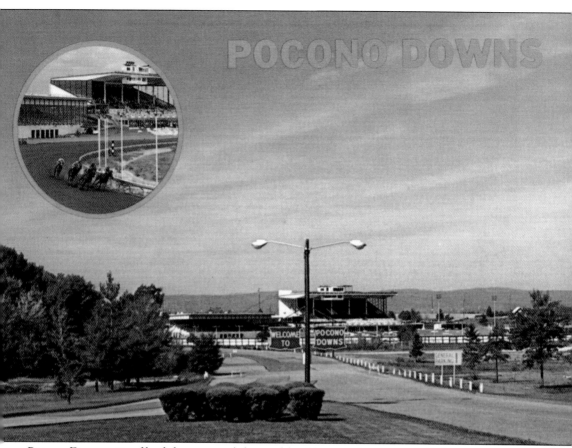

Pocono Downs, site of both harness and thoroughbred horseracing, has provided entertainment in the Wilkes-Barre area for many years. In January 2005, the Mohegan Tribe of Connecticut acquired Pocono Downs and in the ensuing years has made significant improvements to the facility, including the addition of slot machines. In 2010, after then–Pennsylvania governor Edward Rendell signed a bill legalizing electronic table games, the site was expanded yet again. It is currently known as Mohegan Sun at Pocono Downs, and it attracts thousands of visitors daily.

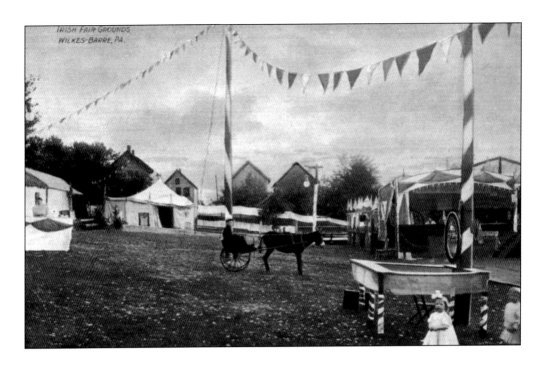

These two images illustrate one of the ways in which the various ethnicities provided entertainment to their friends and neighbors. It is unclear as to where exactly this fairground was located, but it may have been in what is now East End. When the Irish immigrants came to the area to work in the mines, they settled, along with the German immigrants, in what used to be called Five Points, now East End.

Five

VISITING DIGNITARIES

Theodore Roosevelt visited the area several times when he was president and when he was not president. He came to Wilkes-Barre to work with John Mitchell and Fr. John Curran on behalf of the anthracite miners in 1905. Shown in this photograph, Roosevelt (accepting the flowers) is visiting the monument to honor those who died during the Battle of Wyoming in July, 1778.

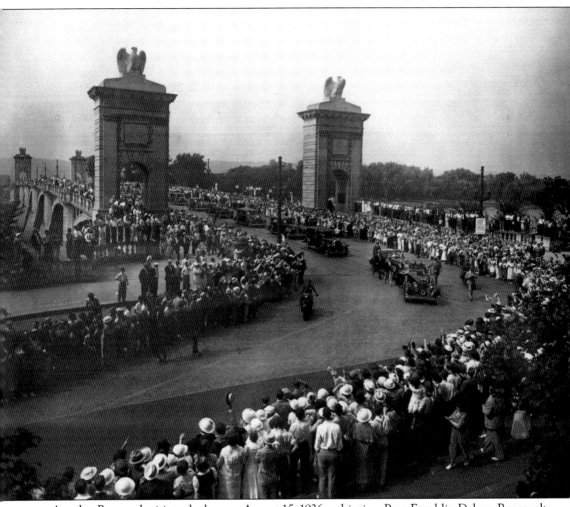

Another Roosevelt visit took place on August 15, 1936—this time Pres. Franklin Delano Roosevelt (1933–1945). Shown in the photograph is FDR's motorcade traveling over the Market Street Bridge into Wilkes-Barre. This was his first visit to Wilkes-Barre that year; because of the devastation caused by the flood of 1936, he had been touring the Northeast. He stopped briefly to view the construction of the dike project. His next visited later in the year, on October 29, to speak to the crowds as part of his reelection campaign.

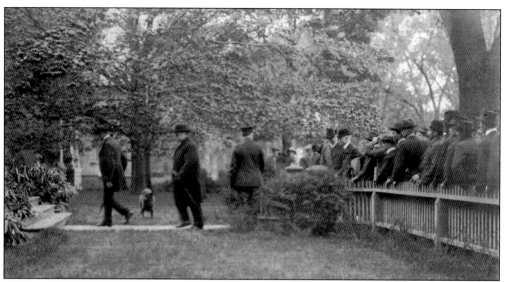

This photograph shows William H. Taft (center, walking with umbrella) visiting a home in Wilkes-Barre. Taft visited Wilkes-Barre twice, on May 13, 1915, to speak at a chamber of commerce meeting, and again on June 10, 1919, to speak at the Wilkes-Barre Institute's graduation ceremony. Both times, he stayed at the home of his friend Judge John Butler Woodward at 100 South River Street. Taft is the only person identified in this photograph, dated 1905.

These men and women are not well-known dignitaries but are important individuals all the same. The photograph shows a group of Civil War veterans. The occasion was a reunion of the men and women in 1929, almost 75 years after the end of the war. How young some of these people must have been at the time of the war!

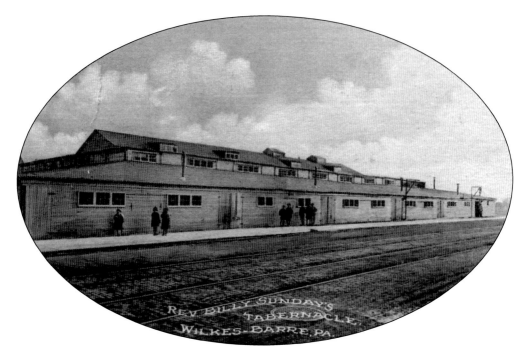

The Reverend William "Billy" Sunday traveled the country preaching his beliefs, reaching over 100 million people before he died in 1935. His ministry would come to town and, working with local religious leaders, construct these temporary tabernacles to house the anticipated crowds. And those crowds would come to hear the man speak. Sunday was a strong and outspoken supporter of Prohibition. It is said that his preaching played a significant role in getting the 18th Amendment to the Constitution passed.

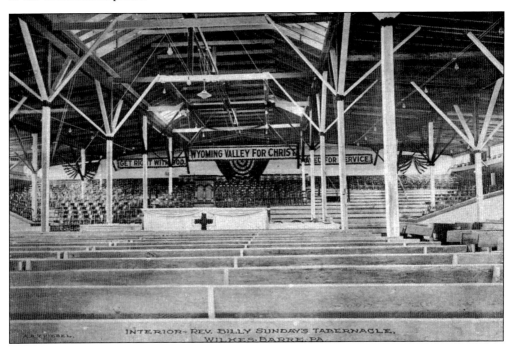

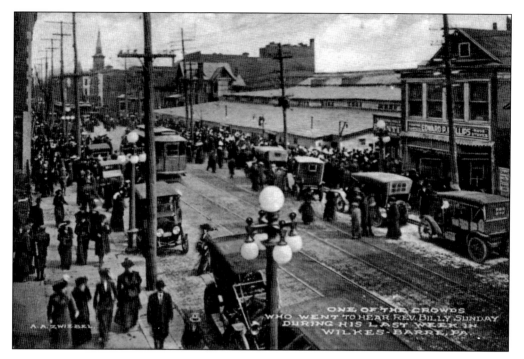

In January 1913, agents of Reverend Sunday arrived in Wilkes-Barre and began construction on a large tabernacle located on South Main Street. The tabernacle was formally opened on February 23, 1913, when Sunday arrived in town. Over the following six weeks, more than 650,000 people attended Sunday's services. It is obvious that Sunday drew crowds in Wilkes-Barre just as he did in other cities and towns he visited.

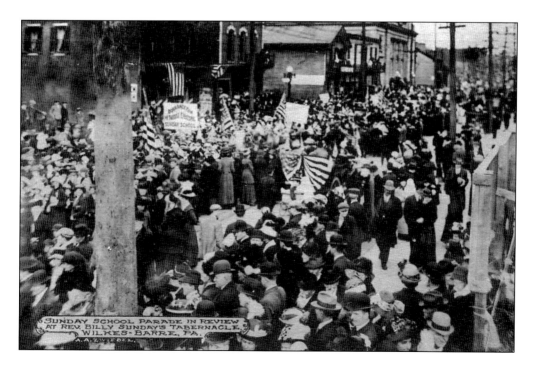

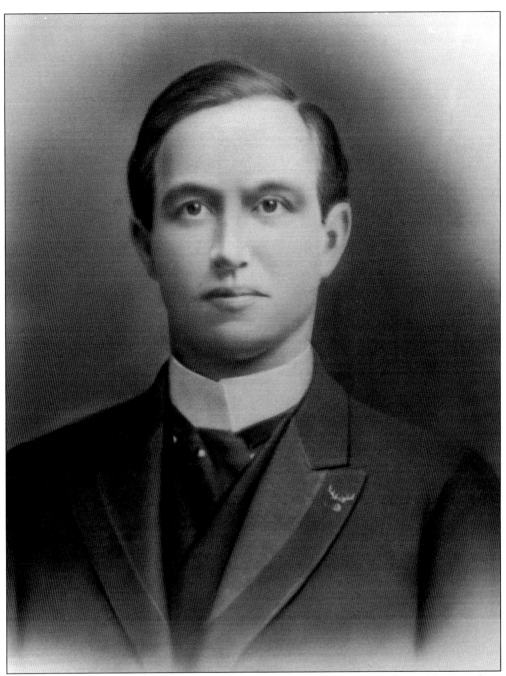

John Mitchell (pictured), labor leader and president of the United Mine Workers of America from 1898 to 1907, paid many visits to the city to meet with Fr. John J. Curran. Working together, the two men convinced Pres. Theodore Roosevelt to force the anthracite mines to offer a reasonable work week and pay rate for the mine workers.

Six

CHANGING
TRANSPORTATION

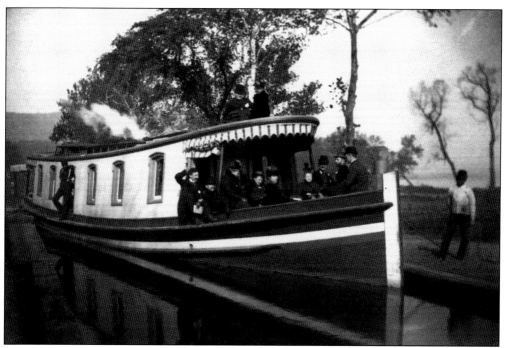

The canals transported people as well as goods. This boat traveled from Wilkes-Barre to Harrisburg and Philadelphia around 1880. It took 24 hours to make the trip via the canal. The first passenger canal boat was launched in May 1831. The Wyoming Division of the canal system was unique; instead of running parallel with the Susquehanna River, it ran along the eastern side of the city. This was done to preserve the beauty of the River Common. The Wyoming Division of the canal was completed in 1834.

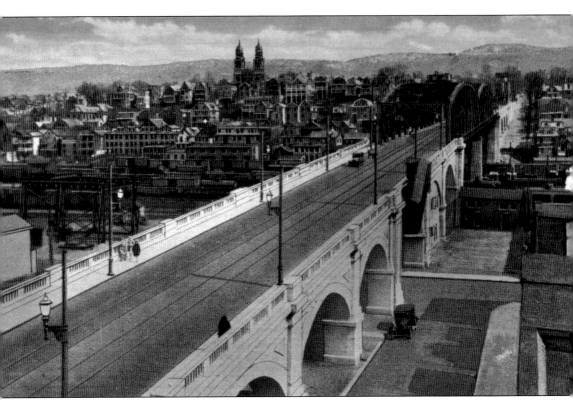

This photograph shows the South Street Bridge, constructed in 1925. It was reconstructed and renamed the Ellis Roberts Bridge in 1991. The canal and railroad lines ran beneath the bridge. The bridge connects the downtown area to the Heights section of the city. The bridge remains today, only now it carries vehicles over South Pennsylvania Avenue, Wilkes-Barre Boulevard, Holy Redeemer High School, and St. Nicolas Church and school.

This c. 1906 photograph shows a team of horses pulling a cart along a steel and wood Market Street Bridge. The Hotel Sterling is visible in the background, as is another team of horses. The old courthouse on Public Square can be seen farther back in the photograph.

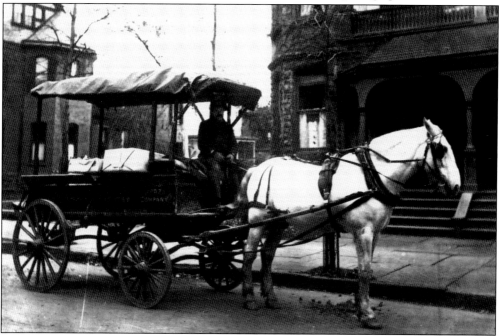

This photograph illustrates an early form of travel, the horse and buggy. Even though this image is of a delivery vehicle, it shows how travel in Wilkes-Barre and in the United States changed over the years. The horse-and-buggy way of travel, and delivery, continued even after the horseless carriage, or automobile, became a popular mode of transportation. This is primarily because people were not able to afford an automobile when they were first on the market.

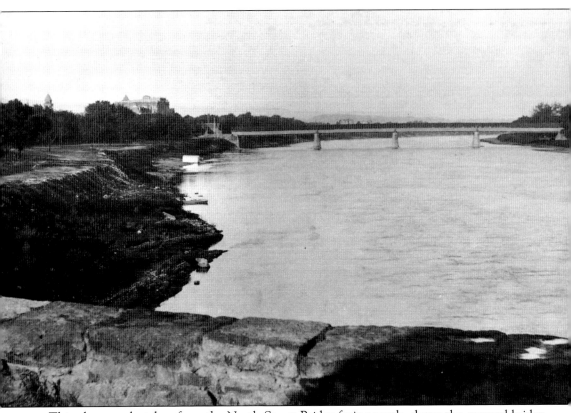

This photograph, taken from the North Street Bridge facing south, shows the covered bridge at Market Street. The tollbooth can be seen on the Wilkes-Barre side on River Street. Also visible along River Street is the Music Hall and the Hollenback Coal Exchange. To the left of the bridge, the top of the courthouse on Public Square is visible, and several large homes can be seen in the distance.

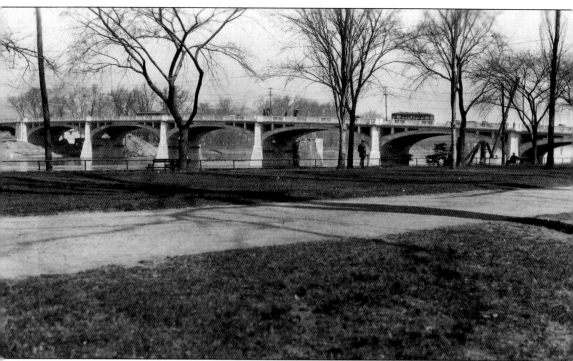

Seen in this photograph, c. 1929 is the recently opened new Market Street Bridge. Note one of the piers of the old bridge can be seen beside the bridge. The concrete structure was begun in 1926 and completed in 1929. The bridge was constructed of concrete to withstand the many floods, ice jams, and other weather related incidents that damaged previous bridges at that location. Trolley tracks were added to this bridge along with what cannot be seen in this image but what the bridge is well known for: the four limestone eagles atop pylons, two at each entrance to the bridge.

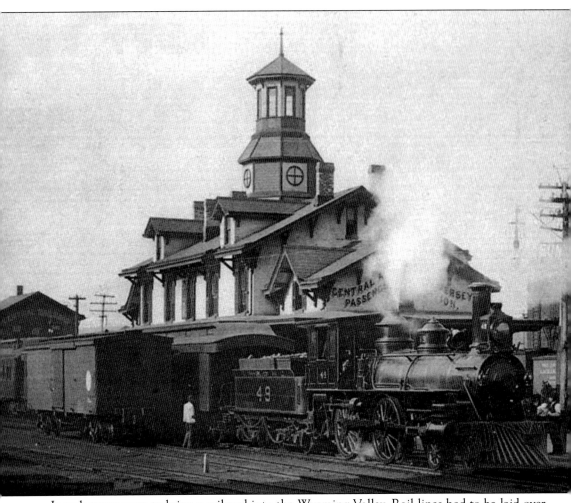

It took many years to bring a railroad into the Wyoming Valley. Rail lines had to be laid over the mountains that surround the valley. The idea for the railroad was conceived in 1838, and the line was not completed until 1866. This c. 1866 photograph depicts the very first passenger train to enter Wilkes-Barre, on March 31, 1866.

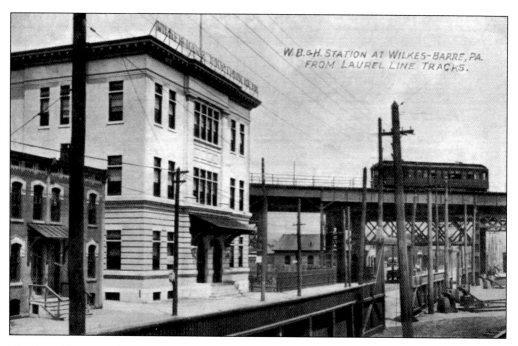

W. B. & H. STATION AT WILKES-BARRE, PA.
FROM LAUREL LINE TRACKS.

The Laurel Line, an electric commuter train, was in use from May 1903 to December 1952, carrying passengers between Wilkes-Barre and Scranton. It was one of the few ways to travel between these two cities. The Laurel Line made several stops between Wilkes-Barre and Scranton, the favorite stop being at Rocky Glen Amusement Park in Moosic. The creation of the Laurel Line opened up employment, shopping, and entertainment opportunities to the residents of communities along the route, including Pittston and Dunmore. Powering the interurban railroad was an electrically charged third rail; this third-rail system was very dangerous.

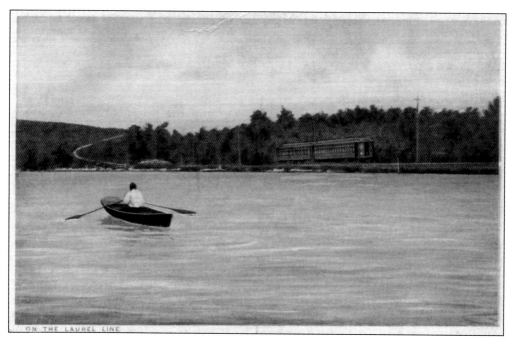

ON THE LAUREL LINE

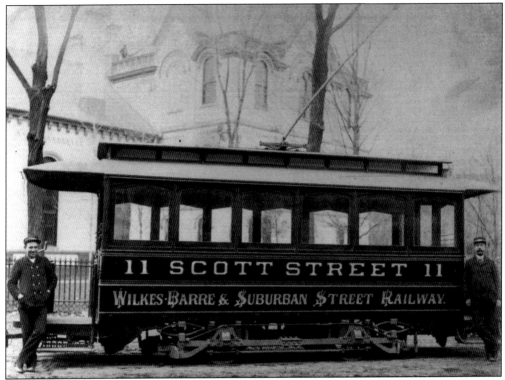

This photograph was taken on Public Square in downtown Wilkes-Barre around 1890. The third Luzerne County Courthouse is visible in the background. This streetcar, or trolley, ran along Scott Street in what is now the East End section of the city.

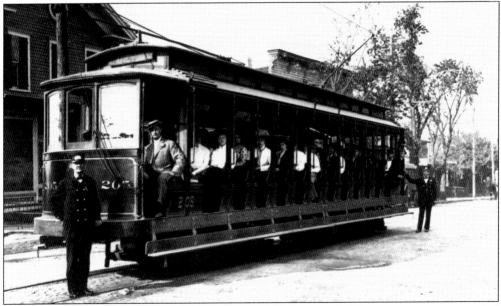

The Carey Avenue Streetcar is shown in this c. 1910 photograph. This open streetcar traveled from Public Square south to Carey Avenue and across the Carey Avenue Bridge into the westside communities of the Wyoming Valley, such as Larksville and Plymouth.

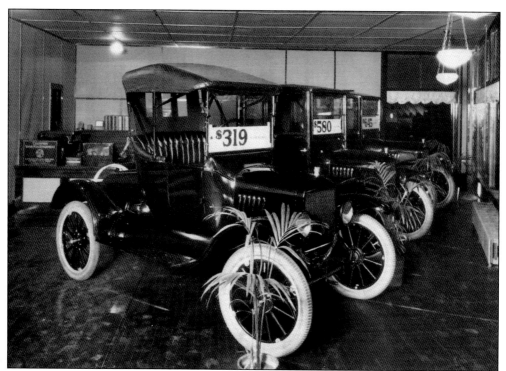

In 1920, automobiles were significantly less expensive than they are today. However, people also earned a great deal less back then. This c. 1920 photograph shows vehicles in a showroom. The cars range in price from $319 to $645. The first man in the valley to own an automobile was Charles W. Lee.

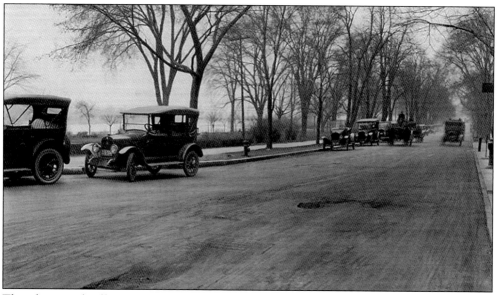

This photograph offers a view of North River Street, between West Market and Union Streets, in 1920. Note the various types of vehicles along the street, and the potholes in the dirt road. The cars are parked along the River Common; the Susquehanna River can be seen on the left side of the photograph.

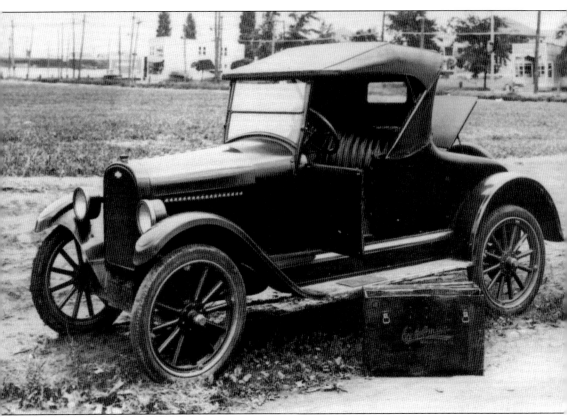

This photograph shows one of the vehicles driven by the Ace Hoffman photographers, who were primarily responsible for many of the vintage photographs in the Luzerne County Historical Society's collection. Their photographs were also used for real-photo postcards. Many of their photographs were taken from an airplane, some of which can be seen in an earlier chapter of this book.

Seven

GROWING COMMERCE

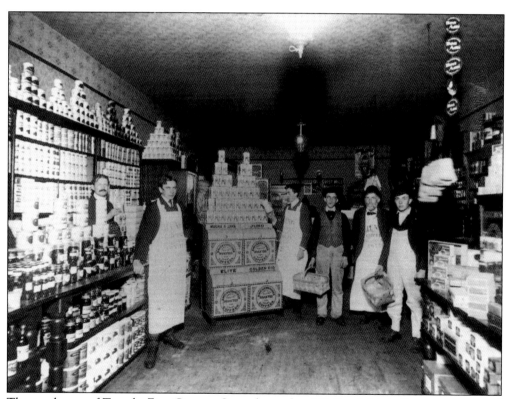

The employees of Toombs Fine Grocery Store, located at 343 South Main Street, are pictured here around 1900. Toombs was a typical grocery store around the turn of the last century. Small grocery stores like this one were found on nearly every street corner in every neighborhood in Wilkes-Barre. When the large grocery chains, such as Acme Market, came to town, however, these friendly corner stores faded away.

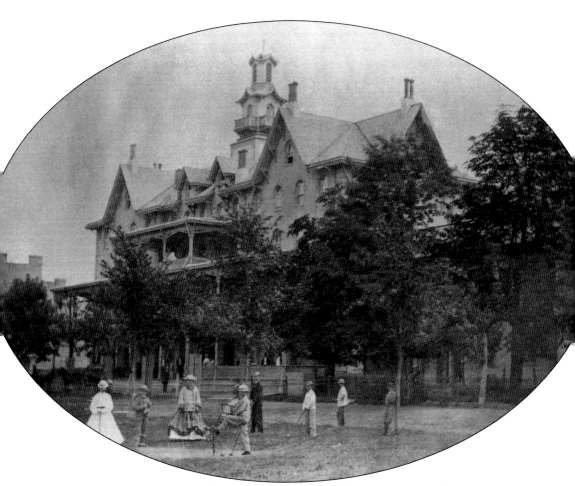

The Wyoming Valley Hotel, or House, as it was initially called, was a beautiful Victorian structure located along what is now South River Street. This photograph, from around 1873, shows children of the era playing a game of croquet while their parents watch from the hotel's porch. After surviving floods and fires, this magnificent structure was torn down in 1909.

Over the years, people arrived in Wilkes-Barre for a variety of reasons. Some businessmen came to town to look for land on which to build a factory or mill. In the early 20th century, the city was an entertainment destination, thanks in part to its many theaters. Because of the area's growing popularity with travelers and tourists, the need arose for places to house them overnight.

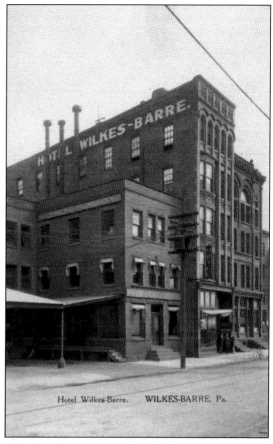

Hotel Wilkes-Barre. WILKES-BARRE, Pa.

In this photograph of East Market Street looking toward Public Square, several hotels can be seen, including the Terminal, the Redington, and Hotel Hart. The Redington, the only hotel still standing, opened in 1906; it is now part of Genetti's complex. On the right side of this image is the station for the Lackawanna and Wyoming Valley Railroad, and the third county courthouse is visible in the distance.

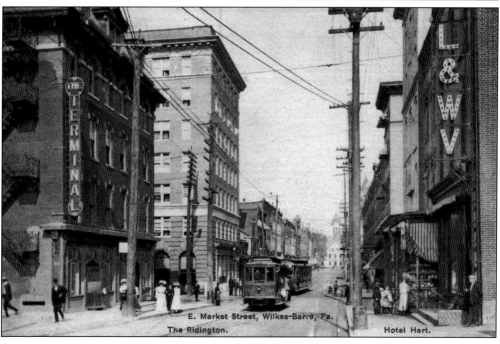

E. Market Street, Wilkes-Barre, Pa.
The Ridington. Hotel Hart.

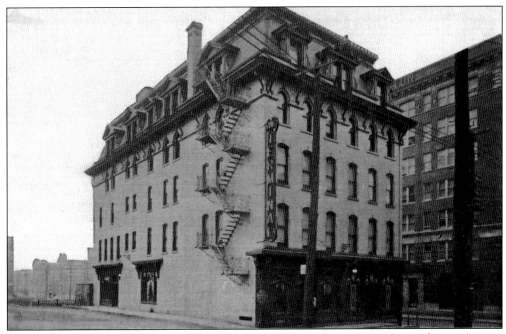

The Terminal Hotel, shown here, was located on the corner of what is now Pennsylvania Avenue and East Market Street. Just to the east of the building, not visible in this photograph, is the railroad station, and to the west, on East Market Street, is the Laurel Line Station. To the right of the Terminal, just across Pennsylvania Avenue, is the Redington Hotel.

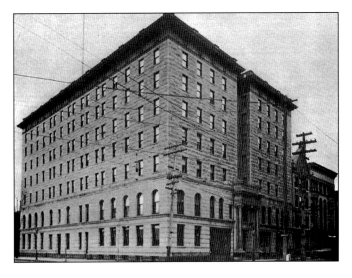

This c. 1906 image shows the Hotel Sterling. This building replaced the Music Hall on the corner of North River and West Market Streets near the Market Street Bridge. The hotel opened in 1898, offering 175 rooms and 125 bathrooms. At the time, it was the largest hotel in the area. Over the years, parties, dances, proms, meetings, and weddings were held here. By the 1980s, however, the hotel was doomed; it still stands, but unfortunately its end may be near.

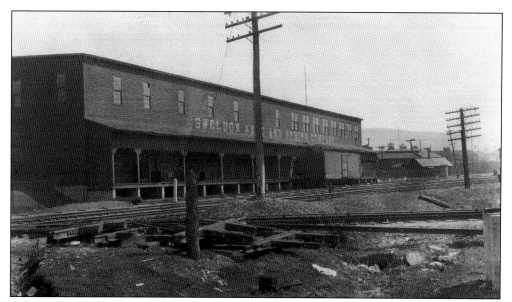

In late 1886, Sheldon Axle and Spring Company was reorganized and enlarged. Under its new name, Sheldon Axle Works, it moved from Auburn, New York, to Wilkes-Barre. At one time, the factory covered approximately 14 acres in the city and employed nearly 1,200 men. The company built axles for carriages and wagons.

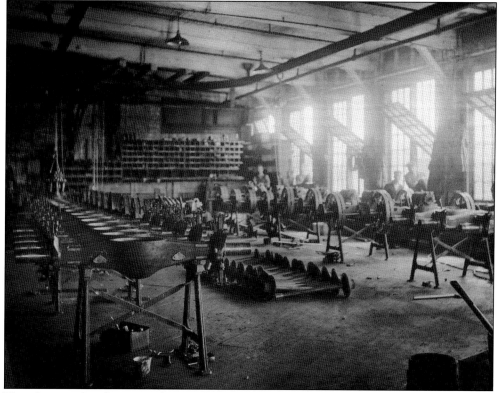

This photograph, taken around 1930, offers a look inside the Sheldon Axle plant and the men at work. Also seen are axles of differing styles in various stages of the production process.

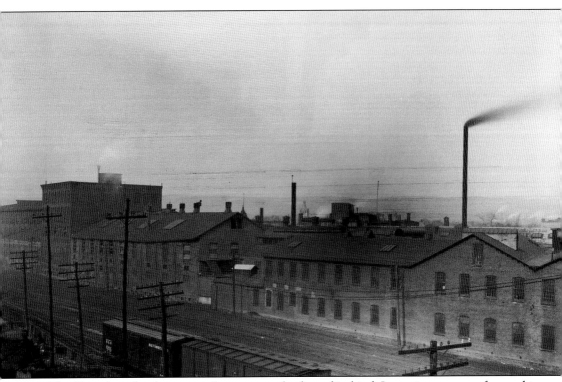

The Hazard, as this factory was known, was the first of its kind. Iron wire was manufactured in this plant beginning in 1868. The company moved from Mauch Chunk, Pennsylvania—now Jim Thorpe—to the city of Wilkes-Barre, beginning operations in two small brick buildings near the corner of Ross and Fell Streets. The business expanded to cover approximately two acres and was the second-largest business of its kind in the United States. The company manufactured bare and insulated copper wire, iron and steel rope that was used for mine shafts, inclined planes, elevators, ferries, and railways.

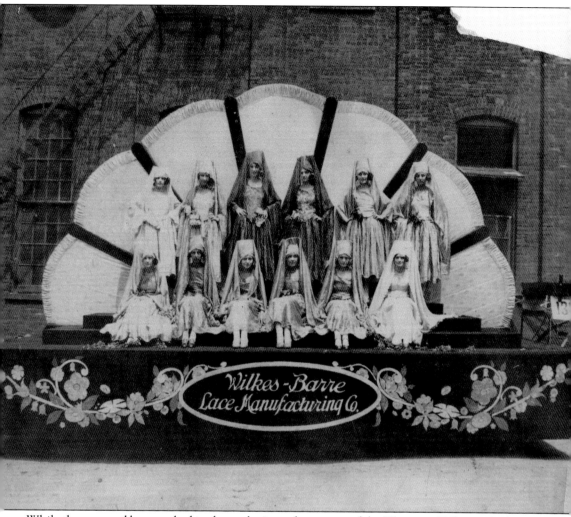

While the men and boys worked in the coal mines, the women of the Wyoming Valley worked in the textile industry, at companies such as the Wilkes-Barre Lace Manufacturing Company. Some of those women are shown here, around 1930. The Wilkes-Barre Lace Manufacturing Company was established on April 1, 1885, to supply the United States with Nottingham lace curtains, previously made solely in England.

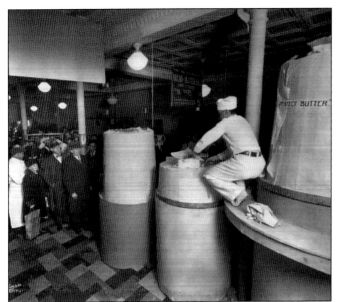

A line of customers watch butter being made at Percy Brown's. Percy Brown started out in the retail business as a delivery boy in 1893. In 1905, he purchased a meat market and began an empire. In November 1909, the business moved to 24-26 East Northampton Street, and in 1910, a delicatessen was added. The business changed its name to Percy A. Brown and Company and added new food lines, fresh fruit, and vegetables. In 1920, the addition of a cafeteria and expansion into 30-32 East Northampton Street took place.

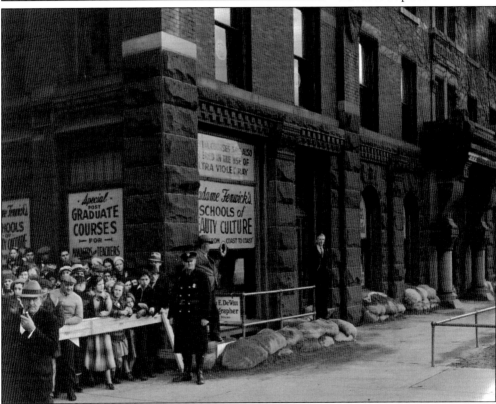

The Hollenback Coal Exchange building, shown here, was home to many businesses over the years. Located across from the Hotel Sterling on South River and West Market Streets, the Coal Exchange can be seen in old photographs standing next to the Wyoming Valley Hotel. The building, completed in 1890, consisted of six stories of office space and housed the first passenger elevator in the city.

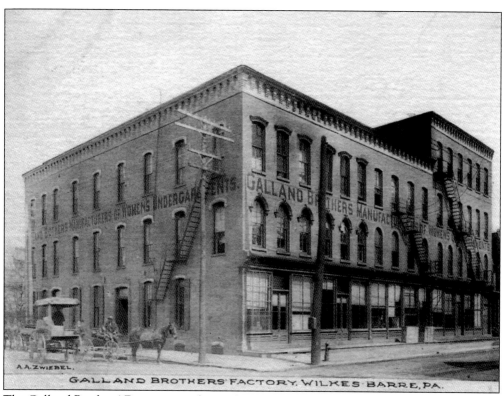

GALLAND BROTHERS' FACTORY. WILKES-BARRE, PA.

The Galland Brothers' Factory manufactured women's and children's muslin undergarments. It was located on the corner of South and South Washington Streets. Over 6,000 garments were made at this factory each day by its more than 600 employees.

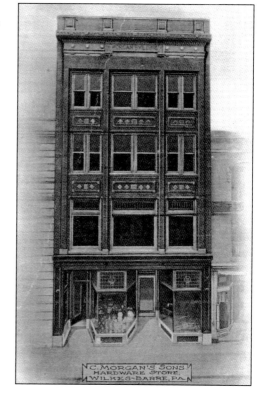

C. MORGAN'S SONS HARDWARE STORE WILKES-BARRE, PA.

C. Morgan's Sons Hardware Store was located on West Market Street in downtown Wilkes-Barre. One of the first of its kind in the city, it was similar to the small hardware stores of today, offering general household and home repair items. There is not much written in history books about this small, family-owned business.

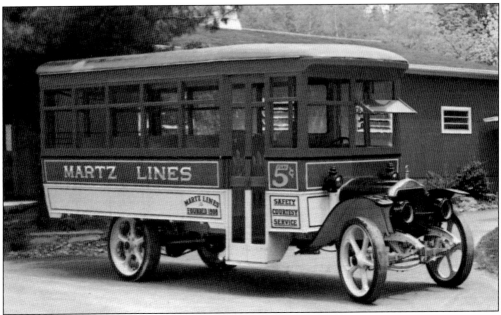

The photograph above shows an early bus in the Martz fleet. Frank Martz worked in 1908 in his father's general store in Avondale. He realized that people would prefer another way to travel to towns along the Susquehanna River. He started with one vehicle, a touring car, and became an immediate success. In 1912, Martz took over a bus line that operated between Wilkes-Barre and Plymouth, and he designed his first bus, shown above. By 1922, the fleet had grown to 39 buses; the rate was 5¢ a ride until 1952. In 1927, the Frank Martz Coach Company was born. Frank Martz Jr. took over the company upon the death of his father in 1936 and continued to grow the business, even during the Great Depression and World War II. Today, over 100 years later, Martz Trailways is still in business.

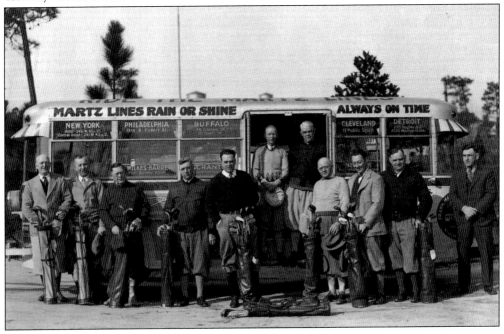

Fred Morgan Kirby, at right, was born in Brownsville, New York. He began his retail career at age 15 by working at Moore & Smith Dry Goods Store in Watertown, New York. Kirby's first store opened on September 10, 1884, at 172 East Market Street, in Wilkes-Barre. Kirby was an outgoing, friendly man who took an active interest in his employees, visiting his stores regularly. Wages for salespeople were low, but the stores offered good fringe benefits. If an employee became sick, the firm secretly stepped in to pay medical bills as well as sick pay, and bonuses were given at Christmas. By 1911, F.M. Kirby & Co., Ltd., had grown to 96 outlets. The name F.M. Kirby still commands respect and admiration in Wilkes-Barre. He shared much of his wealth with the community. Kirby Park, just across the Susquehanna from downtown Wilkes-Barre, bears his name.

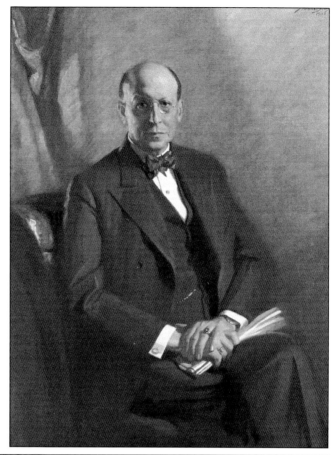

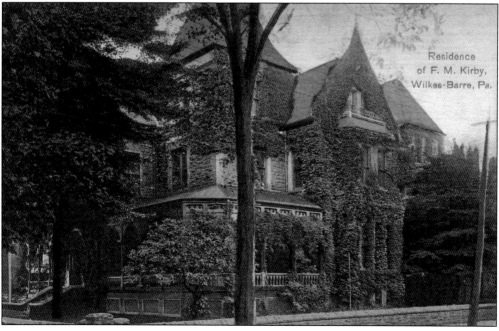

Residence of F. M. Kirby, Wilkes-Barre, Pa.

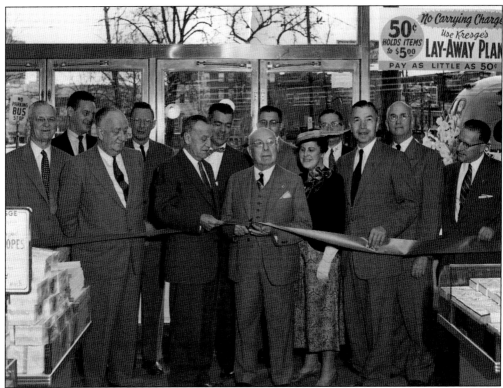

Sebastian S. Kresge, founder of the S.S. Kresge chain of 5-and-10-cent stores, was born in Bald Mountain, near Wilkes-Barre. He began his retail career as a clerk in a hardware store, then worked at a 5-and-10-cent store in Memphis, Tennessee. Starting with two stores in 1899, S.S. Kresge Company was incorporated with 85 stores by 1912. The Kresge store in Wilkes-Barre is seen in the photograph below. That store's ribbon-cutting ceremony is shown above. In the photograph are, from left to right, (first row) L. Verne Lacy (architect), William O. Sword, Mayor Luther M. Kniffen, Kresge, Clara Kresge, Clarence Beerweiler (store manager), Walter H. Wakeman (city native and buyer for the corporation), and Luther P. Green; (second row) A.J. Sordoni Jr. (contractor), Charles H. Miner (chamber of commerce president), H.J. Corsette, William E. King, and R.P. Horner (Kresge district manager). It is interesting to note that Kresge's had a change of name in 1977; it became the Kmart Corporation.

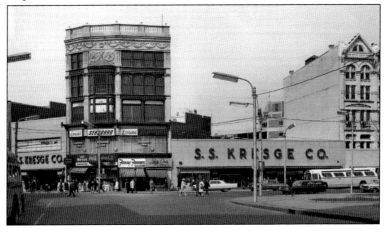

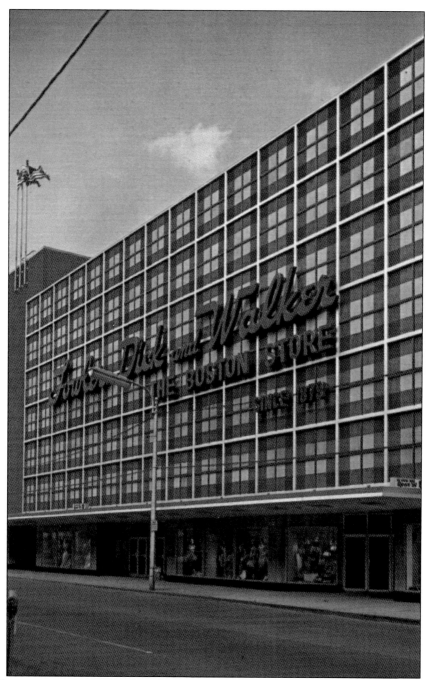

Scottish immigrants George Fowler, Alexander Dick, and Gilbert Walker opened the Boston Store in 1879 on South Main Street. They named their company after Boston wholesalers who gave them credit to get started. The original store was 22 feet wide, 114 feet deep, and had a grand total of 15 employees. In the 1950s and 1960s, this store on South Main Street underwent a massive renovation. It expanded upward, to include five floors and 132,000 square feet. The company expanded, geographically, over the years; stores were built in Nanticoke, Pittston, Hazleton, and Binghamton and Glen Falls, New York.

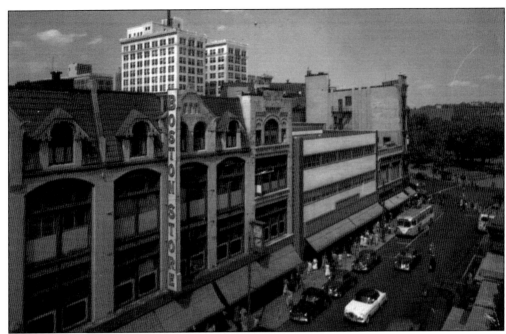

These two photographs offer later views of the Boston Store. The photograph above, looking north on South Main Street, shows that the tartan facade has been removed and windows are now visible. However, it appears the lower parts of the windows have been boarded over. Notice the awnings over the sidewalks to keep shoppers dry in the rain and snow and shaded from the sun. The photograph below shows the South Franklin Street entrance to the Boston Store and the entrance to the two-story parking garage. Except for the addition of two more stories of parking, this scene does not look much different today.

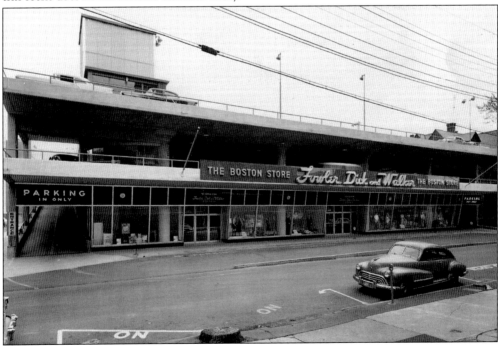

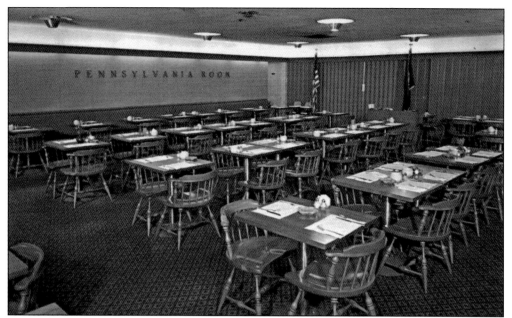

The Boston Store offered several places for customers to eat while they shopped. This photograph shows one of them, the Pennsylvania Room. It offered a cozy place for lunch.

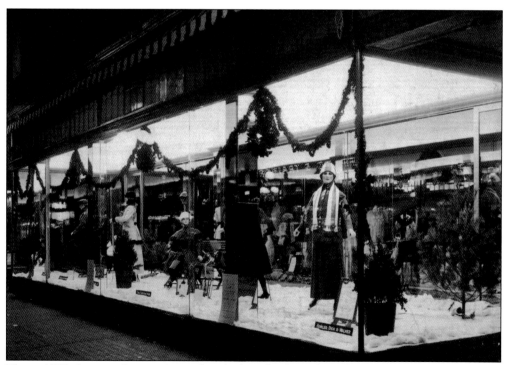

This c. 1950 photograph gives the reader a look at the dressed windows on the South Main Street side of the Boston Store at Christmas. The mannequins are attired with warm clothes, trees are placed along the rear of the display, wreaths hang from garland along the tops of the windows, and fake snow covers the floor. How inviting it must have been!

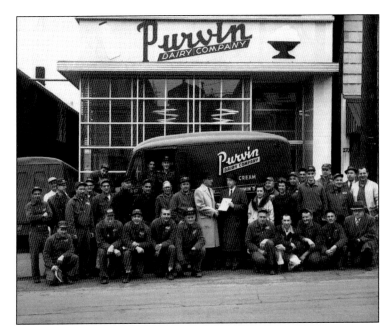

This c. 1961 photograph of Purvin Dairy Company shows the men who delivered milk and other dairy products to households around Wilkes-Barre. Nearly everyone had an insulated metal case on their porch. The residents placed the empty milk bottles (and perhaps a note listing other items) into the box the night before, and in the morning, the empties were replaced with full bottles of milk.

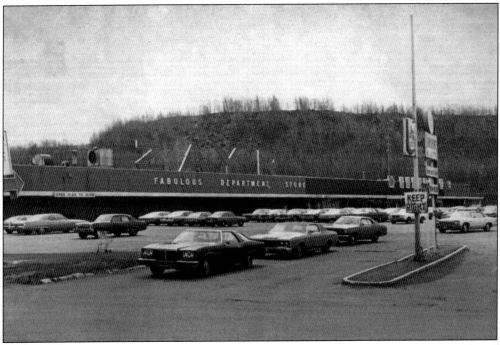

Shown here is one of the first local, family-owned grocery stores, Sunshine Market. The idea of Anthony N. Colonna Jr. in the early 1950s, the market grew to become one of the largest stores in the area, offering friendly service, great meats, fresh produce, and Green Stamps. This store closed in 1994 and relocated a few miles away, eventually closing for good in 2009.

Eight

GOVERNMENTAL GROWTH

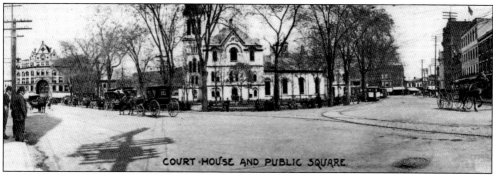

COURT·HOUSE AND PUBLIC SQUARE

As seen in previous chapters, the Luzerne County Courthouse was located on Public Square. Shown in this photograph is the third courthouse on the square. The county government outgrew the previous two, and, in the 1890s, decided that this one needed to be replaced as well. After much discussion, it was decided that the new, much larger courthouse be built along the Susquehanna River near River Street.

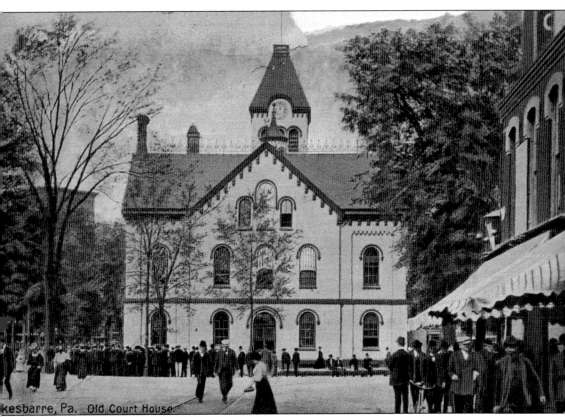

kesbarre, Pa. Old Court House.

Public Square was a very busy place, as can be seen in this photograph from the late 1800s. Not seen in this photograph is something the county certainly would have wanted to be kept hidden—the gallows. Public Square had its own set of semi-public gallows in the yard near the courthouse. The last public hanging was on May 4, 1905; following that, and until hangings were outlawed, prisoners were hanged behind closed doors.

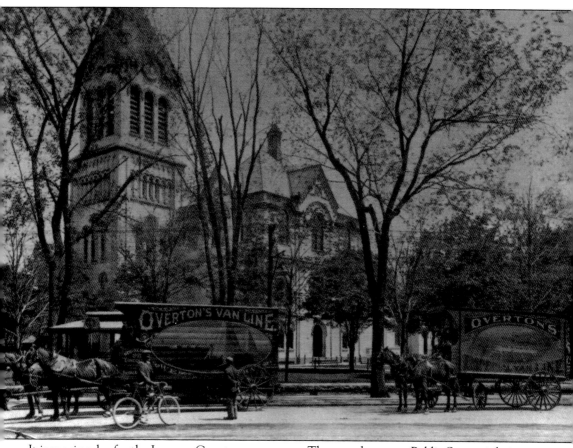

It is moving day for the Luzerne County government. The courthouse on Public Square is being emptied and will soon be demolished to make room for a public park and open space. This photograph shows the moving vehicles waiting to be loaded to make the trip to North River Street and the new courthouse. (Author's collection.)

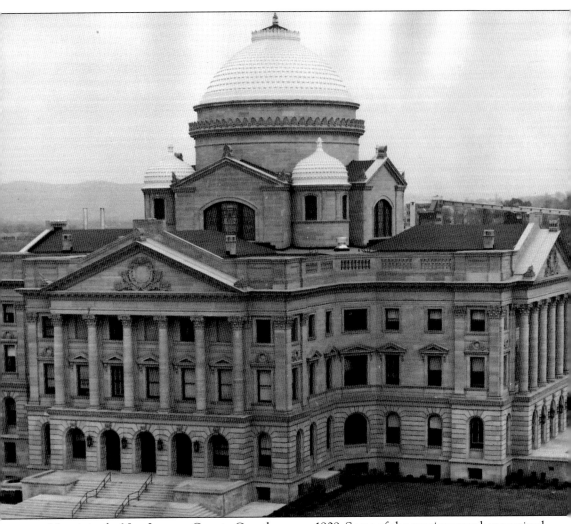

Here it is, the New Luzerne County Courthouse, c. 1909. Some of the moving vans have arrived and will soon be unloading their freight into this massive building, which has been under construction for almost a decade. This was called the "million dollar courthouse" because the budget for its construction was approximately $1 million; the finished building actually cost over $2 million. Unfortunately, it was not built without controversy and greed.

The Conyngham Post 97, Grand Army of the Republic Memorial Hall was once a meeting place for Civil War veterans. The hall once held a collection of flags, weapons, and literature from the Civil War. The collection, including the cannons seen across the front of the building, was moved to the 109th Armory in Kingston, where it remains today.

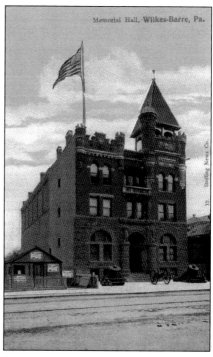

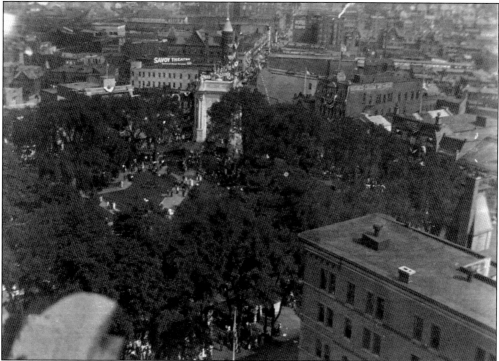

This photograph shows the parade honoring the returning heroes of the 109th Field Artillery on May 19, 1919, after World War I. The men returned home to crowds celebrating their safe return. The soldiers are seen marching over East Market Street after being deposited by train back in Wilkes-Barre. The vehicle in front of the men carries Col. Asher Miner and the members of his staff.

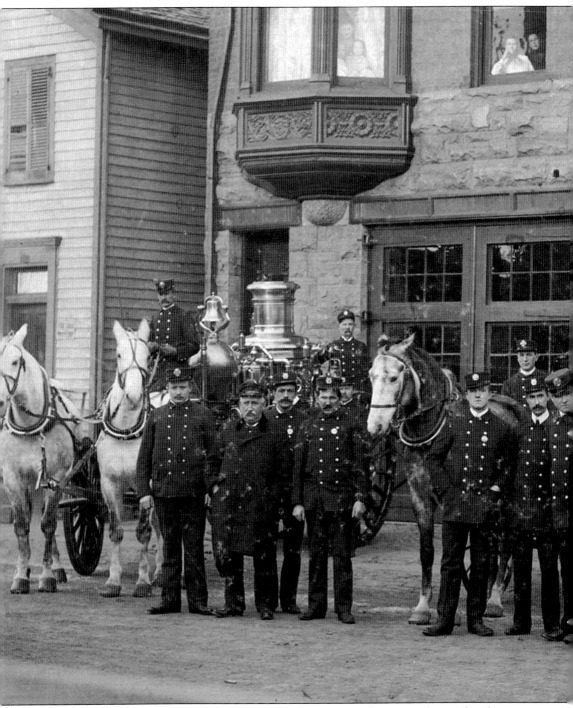

In 1806, upon its incorporation as a borough, plans were under way to form a fire department in Wilkes-Barre; this, in a time when all of the buildings in the borough were made of wood. Leaders of the day decided to look into purchasing a fire engine. Nothing was done besides creating a resolution that required every household to purchase a fire bucket. Finally, in 1818, the city managed to purchase an engine, the Davey Crockett. It was a used, hand-operated pump

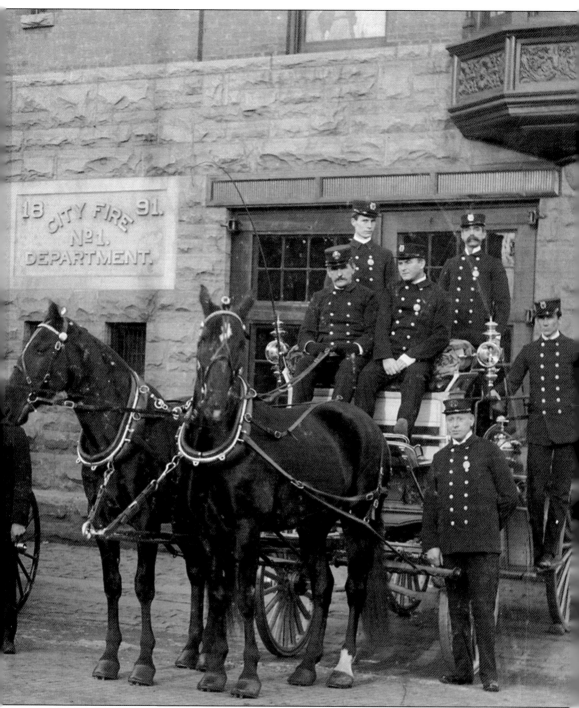

purchased from the Philadelphia Fire Department for the sum of $300. By 1905, the Bureau of Fire had 13 pieces of apparatus, all horse-drawn. Among the pieces were five steamers. In April 1915, the Bureau of Fire was fully staffed by career firefighters. This photograph of the No. 1 fire company was taken before the department motorized, possibly between 1915 and 1920. By 1920, every piece of apparatus was motorized.

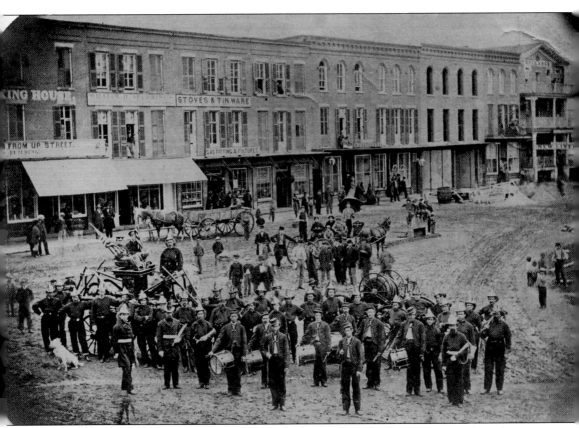

The Wilkes-Barre Fire Department began as a bucket brigade. A spotter was selected in every neighborhood to look for signs of fire, smoke, and flames. The spotter would yell out "fire, fire, fire!" after seeing smoke. This was the signal to neighborhood residents to fill their water bucket and place it on the front porch for the firemen to pick up on their way to the fire. Shown in the photograph, a very early image of the fire department, are the members of the bucket brigade and the department's band. Even their dog is visible in the picture.

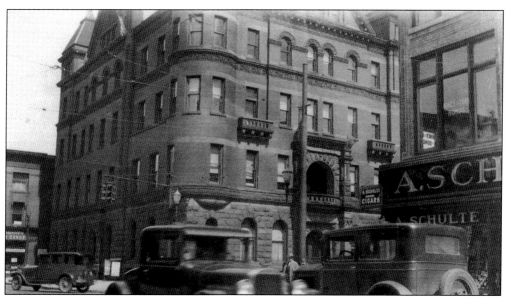

When Wilkes-Barre was incorporated as a borough on March 17, 1806, Lord Butler was the first president of the town council. On May 4, 1871, Wilkes-Barre was chartered as a city; it became a third-class city on September 22, 1898. The city's seal, which is created in stained glass over the front door, illustrates the belief that the city was "busy as a beehive." The Victorian detailed building was completed in 1893. It now houses the offices of the city, including the mayor. Prior to the construction of this building, the city council and the mayor met in offices in the Coal Exchange Building. The photograph below was taken in 1933.

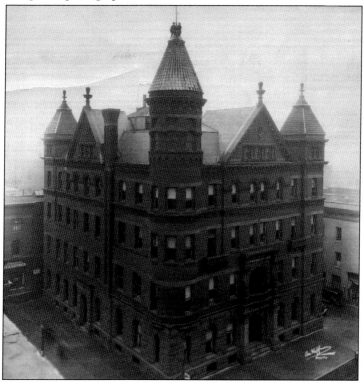

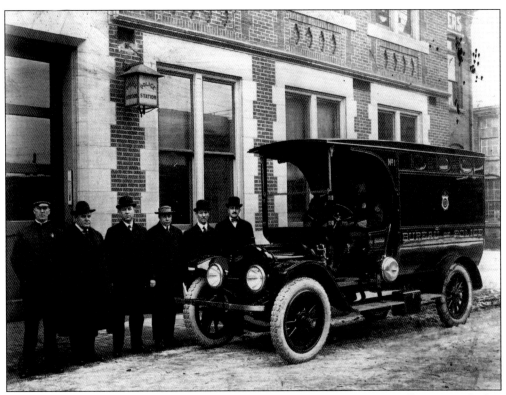

Wilkes-Barre's first police force was formed in 1872. The department originally consisted of 18 men. The Wilkes-Barre City Police Department provides law enforcement and public safety services to a population of over 43,000 residents and visitors, in an area covering seven square miles. The department is staffed by 91 sworn personnel and seven civilians. Its mission statement is to effectively protect life and property, reduce crime, and foster an environment of harmony between business, industry, and recreation, thereby enhancing the quality of life in the city.

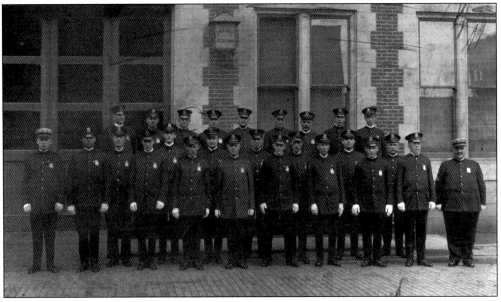

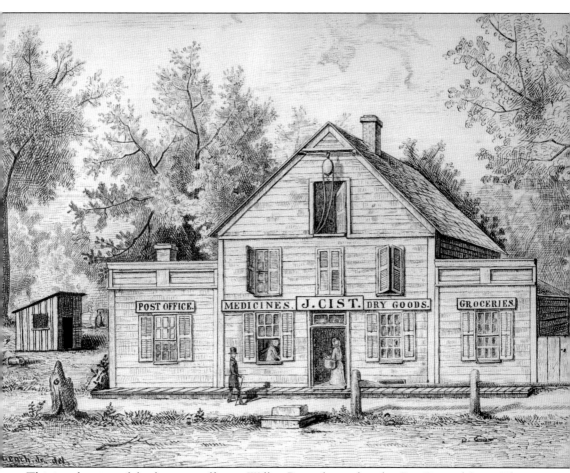

This is a drawing of the first post office in Wilkes-Barre, located in the Cist General Store. The original post offices were located in the postmaster's homes. The first post office was established in the Wyoming Valley in 1794 and Lord Butler was named postmaster. Mail arrived to the post office via a post rider, or a man on horseback, also known as the Pony Express. In 1810, mail was transported by stage coach. The mail arrived in Wilkes-Barre about every two weeks. Home delivery was not available, each household had a box, a sort of early cubby, in the post office, and residents had to go to pick up their mail.

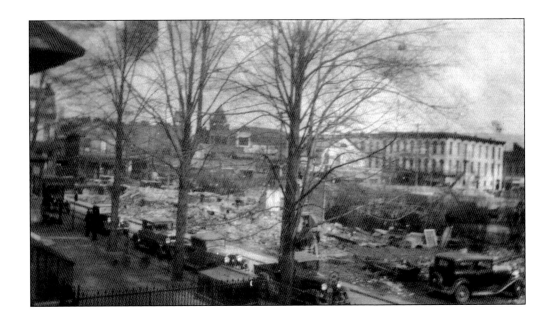

This series of photographs show various stages of construction of the old post office. This building was completed in 1943 and housed the post office until 1967, when the new post office was opened a block away on Ross Street, South Main Street, Pennsylvania Avenue, and Hazel Avenue. (Both, author's collection.)

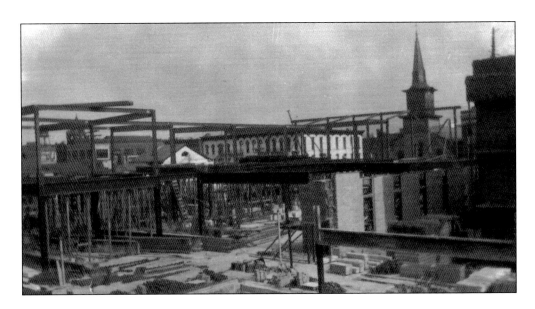

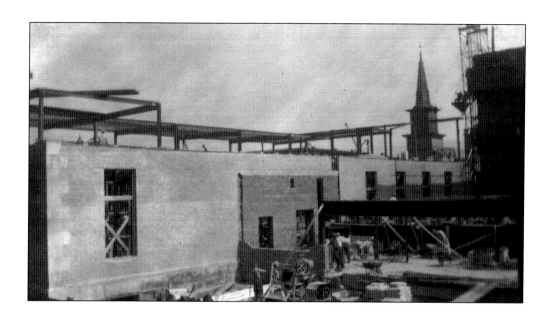

This building was completed in 1943 and housed the post office until 1967, when a new, larger post office was opened a block away on South Main Street, Ross Street, and Pennsylvania Avenue. The building that once housed the mail is now the Max Rosenn Federal Courthouse. (Both, author's collection.)

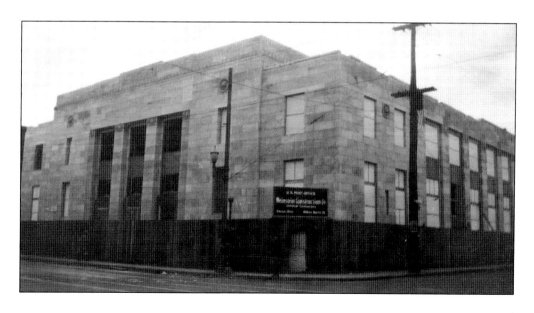

BIBLIOGRAPHY

Harvey, Oscar Jewell, and Ernest Gray Smith. *A History of Wilkes-Barre Luzerne County, Pennsylvania from its first beginnings to the present time; including chapters of newly discovered early Wyoming Valley history.* Wilkes-Barre, PA: Smith Bennett Corp., 1929.

Lottick, Sally Teller. *Bridging Change: A Wyoming Valley Sketchbook.* Wilkes-Barre, PA: Wyoming Historical and Geological Society, 1992.

Moss, Emerson I. *African-Americans in the Wyoming Valley, 1778–1990.* Wilkes-Barre, PA: Wyoming Historical and Geological Society and the Wilkes University Press, 1992.

Moss, Juanita Patience. *Anthracite Coal Art by Charles Edgar Patience.* Westminister, MD: Willow Bend Books, 2006.

Spear, Sheldon. *Chapters in Wyoming Valley History.* Shavertown, PA: Jemags & Co., 1989.

Wick, Harrison. *Greater Wyoming Valley Trolleys.* Charleston, SC: Arcadia Publishing, 2009.

———. *Luzerne County.* Charleston, SC: Arcadia Publishing, 2011.

ABOUT THE ORGANIZATION

What would become the Luzerne County Historical Society began on February 11, 1858, when a group of city leaders met at the Old Fell Tavern to celebrate the 50th anniversary of the first known successful burning of anthracite coal in an open grate. During the meeting Gen. E.L. Dana suggested the establishment of a historical society—a suggestion that was met with unanimous support—and the Wyoming Historical and Geological Society was incorporated in May 1858. The Luzerne County Historical Society is one of the oldest local historical societies in the United States.

The society's mission is to preserve and promote the collective history and heritage of Luzerne County.

The society's name was changed in 2000 from the Wyoming Historical and Geological Society to the Luzerne County Historical Society to better identify it to the public.